from a quilter's GARDEN

That Patchwork Place®

A FRESH CROP OF APPLIQUÉ DESIGNS

Gabrielle Swain

CREDITS

Editor-in-Chief Kerry I. Hoffman
Managing Editor Judy Petry
Technical Editor Sharon Rose
Design Director Cheryl Stevenson
Text and Cover
 Designer Joanne Lauterjung
Copy Editor Tina Cook
Proofreader Melissa Riesland
Illustrator Laurel Strand
Illustration Assistants Bruce Stout
 Robin Strobel
Photographer Brent Kane

From a Quilter's Garden:
A Fresh Crop of Appliqué Designs
© 1996 by Gabrielle Swain
That Patchwork Place, Inc., PO Box 118
Bothell, WA 98041-0118 USA

Printed in the United States of America
01 00 99 6 5 4 3 2

DEDICATION

Black Dahlia, for us, always in bloom.

ACKNOWLEDGMENTS

Jane Baird, a dear friend who taught me so much about quiltmaking and life, once said, "Gabrielle, say thank you and shut up." Saying "thank you" is easy, but I still haven't learned to shut up, so thank you:

Barbara Hartman, once again and always, the best of friends at any time.

Jeannette Garnsey, beautiful, insightful, and always ready to share.

Paula Baxley and Katherine Guidry, owners of Nostalgia, Quilts, and Antiques, for a new home in which to test-teach these patterns and for many hours of pleasure in their company.

Jeannette Stewart, Wanda Hettrick, Carol Stahle, Sue Troyan, and all the gang at Nostalgia for putting up with my whirlwind visits through the quilt shop.

Laura M. Reinstatler, editor of *Appliqué in Bloom*. Knowing Laura has truly enriched my life. Just hearing her voice on the phone brightens my day.

Laura McGee, owner of Painted Pieces, whose faith in me has often turned the tide of frustration. Discussing color with Laura has opened new doors.

Dawn Hall and Stacy Michell, from Cherrywood Fabrics and Shades, Inc., respectively. Your fabrics make us all look good.

All the quiltmakers who participated in making quilts for this book: Helen Ruth Brandhurst, Janet Carija Brandt, Joan Burckle, Peggy Cord, Linda Cordell, Ruth Cattles Cottrell, Gail Curnutt, Joan Dawson, Gabriele Fusee, Noreen Kebart, Laura McGee, Marilyn Mowry, Gwen Offutt, Nikki Phillips, and Donna Slusser. I consider it a privilege and an honor to have their work in this book.

Julia S. Sandlin, for quilting "Juicy Fruit" and "Eat Your Veggies." We made the deadline—yahoo!

Sue Hausmann and Viking Husqvarna, for their continued support. Nothing would be finished without my Viking #1.

All the quiltmakers I have met online and while traveling and teaching this past year. You have been a joy and an inspiration.

As always, my family—Ronnie, Charles, Craig, Chris, and Thomas. I am so proud of you. This would not be possible without your support.

Finally, everyone at That Patchwork Place, for their continued support of my work and dedication to quiltmakers throughout the world.

MISSION STATEMENT

WE ARE DEDICATED TO PROVIDING QUALITY PRODUCTS AND SERVICES THAT INSPIRE CREATIVITY.

We work together to enrich the lives we touch.

table of CONTENTS

how does your GARDEN *grow?*

I grew up in a rural community where everyone had a garden. Women worked in their gardens from spring planting to fall harvest. They canned and stored the crop, then started again. This process always fascinated me. I watched each year as the seeds grew to maturity. Colors, shapes, and smells rose from the gardens throughout the spring and well into fall.

Many of these women also quilted. They had large frames that dropped from the ceiling. Friends gathered to quilt, usually completing a project in one day. Lunch often came directly from the garden. The quilters exchanged canned goods and fresh fruits and vegetables when available. Quilting and gardening provided these women hours of companionship.

When I was five years old, I desperately wanted to have a garden of my own. Stealthily removing a strawberry from the refrigerator, I ran to Mom's flower beds and, with my thumb, made my first planting. The strawberry let me down, but my mom did not. Watching me suffer this defeat was too much for her. She bought a few tomato plants, some okra seeds, onion sets, and a small peach tree from the nursery. She and I (mostly Mom, I am sure) planted and watered and waited.

The tomatoes and okra lasted until early winter. The peach tree still stands. My fascination with gardens continues—I now appliqué them. The shapes and colors of the flowering fruits, vegetables, and herbs bring delightful memories. No matter what plant I see, appliqué designs immediately pop into my mind.

I hope you find something in these designs that intrigues you as a quiltmaker. Although appliqué is my method of choice, there are other techniques in the book for you to try. Use these designs in any manner you like. Explore and enjoy!

variety & STYLE

Style is the manner in which artists work. It includes use of media, placement of design, approach to color, and interpretation of imagery. As quiltmakers, we develop style through design choices, which range from traditional geometric blocks to realistic interpretations of nature. Our color choices and the ways we combine and use fabric make our work recognizable. (You mean we have to *use* the fabric, not just collect it? Uh-oh!)

I work in a contemporary style. What does that mean? Do I make irregular shaped quilts? Do I use unusual imagery?

Contemporary quilts are not just quilts that are nontraditional or have unrecognizable patterns. "Contemporary" means "defined in some way by the time in which we are living." My work is contemporary because I use fabrics and techniques that give my quilts a look that is current. I have made a conscious decision not to re-create quilts from the past. Leaving a legacy of *our* time is my goal.

Since appliqué is my first love, I find ways to make it contemporary. Design imagery becomes realistic instead of stylized, blocks move into asymmetrical settings, bilateral symmetry enhances compositions, and pieced elements combine with appliqué to give quilts pizzazz. A working definition of contemporary appliqué might be doing anything that creates the look you desire. No limitations. You have permission to play until it pleases you, the artist.

Contemporary floral appliqué came from practicing what I preach. Realistic designs set on unusual background fabrics take my breath away. Settings that move beyond the traditional grab my attention. The projects in this books include all these elements. Use them as suggested, or turn to "Building Your Quilt" on pages 10–11 and create something that is yours alone. You are the artist now. Show us your style.

As you look through the quilts in the gallery on pages 46–57, notice how each quiltmaker makes a statement. All the block designs are the same, yet each quilter says something different.

Joan Burckle uses a gradated background fabric throughout "Garden Window." The striped fabric she chose for her sashings adds a geometric element without piecing. In "Rainy Days," Laura McGee painted her background and block designs before setting them together. What does this tell us about Joan and Laura as quiltmakers and artists? They approach their work differently, yet both achieve spectacular results.

If you are a beginning quiltmaker, study the works in the gallery. Which ones do you like? What would you do differently? This is one way to develop style. If you are an advanced or intermediate quiltmaker, do the same, keeping your completed quilts in mind. Do the more traditional quilts appeal to you? Do you want to break new ground?

Try a variety of styles during the discovery process. You may discover you prefer working in many styles. Your style may be the way you use color and pattern, or it may be the type of quilt you make. Exploration does not stop here. Push yourself further. Make these blocks yours, no matter what your style.

fabric SELECTION

Background Fabrics

Dark background fabrics

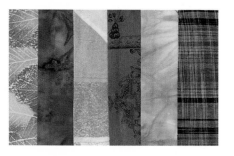

Gray background fabrics

Today's fabrics provide us with infinite selection. So many choices, so little time. Where do we start when choosing fabrics for a new project? In appliqué, the background fabric is a good place to begin.

There are delightful fabrics available that provide rich texture and color. Why not try some of these as backgrounds? Background fabric sets the stage for any appliqué design. The visual interest these fabrics add to any appliqué project is immeasurable. I am on a mission to get everyone to stretch their choices—no more solid fabrics for appliqué backgrounds!

Look at still-life paintings, or paintings of any kind. Usually, you will see a background of color or texture placed on the canvas, supporting the imagery in the foreground. Do the same thing with background fabrics. Look for a fabric that creates the atmosphere you want in your quilt. I like high contrast and dramatic value change in my work, but subtle, sophisticated color and value also appeal to me. For a dramatic look, I choose a dark background. For more sophisticated projects, gray backgrounds work beautifully.

Study fabrics carefully for changes in pattern and color. Look for a fabric with just a touch of personality. Fabrics with too much color and pattern detract from the appliqué. No one wants to devote time to a project only to realize the appliqué disappears into the background.

Unsuitable background fabrics with too much color and pattern

Suitable background fabrics

What atmospheres do different fabrics create? Each of us responds differently to fabric design, but here are some examples. Small calicoes give an antique, Country feeling. Homespun stripes and plaids create a primitive look. Bold stripes produce a contemporary, modern feeling.

The background fabric in "Delicious" on page 54 is blue-violet. Nothing spectacular appears in the pattern, just a touch of texture. I chose it as a color exercise. The blue-violet made for thoughtful color choices in the design work. Blue-violet, orange, and green are complements on the color wheel. Using a variety of greens brought the background to life. These greens also gave the fruit and flowers support and dimension.

What do you want viewers to feel when they see your quilt? By using a variety of background and setting fabrics, you keep viewers at your quilt longer; they want to explore every aspect. Each viewer is delighted by something different. Add unusual background fabrics to your appliqué just once. I know you will find the change rewarding.

Small calicoes suitable for background

Homespun, plaid, and boldy striped fabrics suitable for background

Nature: The Master Palette

Since my work is realistic in style, choosing appliqué fabric is easy: Nature is my guide. If I appliqué a peach, it looks like a peach.

Each of the block instructions includes color guidelines. For specific information on fruits, vegetables, and herbs, look in seed catalogs, which are wonderful resources for all the patterns. Vegetables, for instance, grow in many different varieties. These varieties offer an unlimited palette. One exciting discovery for me was purple bell peppers, in particular a new variety called "Lilac Belle." The addition to the blocks of the beautiful purple bell pepper is stunning. (See "Eat Your Veggies" on page 57.) Look through seed catalogs before starting your work. Their inspiration is a good starting point for fabric selection.

Think of the color wheel when beginning a block. The simple primary colors at right started the fabric-selection process for the Currant block. Combining these colors in one block creates drama without detracting from the natural quality of the appliqué. Why? Nature combines these colors in landscapes all around us.

Notice also that values change within the currants. Remember the value scale when working with any color. Value gives the appliqué dimension and separation. Without value changes, the currants would look not like currants, but like lumps of fabric.

Watercolor background fabrics

Red, yellow, blue, and orange color run for currants

Value scales of red, yellow, blue, and orange

Value/color run of pinks

Green and orange color run

Autumn leaf color run

In addition to value, use variations of color to define and separate appliqué elements and to add interest to the design. The Peach block depends on just two colors for its beauty, yet notice how different the Peach blocks in the gallery are. Some feature yellow-greens combined with true greens; others use dark and medium greens.

Knowledge of color theory is valuable to any quiltmaker. Learning that primary colors blend to make secondary colors is just the start. Carry that forward into secondary colors, which combine to make tertiary colors. Blend opposites—red and green, blue and orange, violet and yellow—and you will discover that in the middle is gray. Gray is the universal neutral, not beige or ecru or tan. While the play of color adds beauty to any quilt, it is the play of value and intensity that adds sophistication. Remember, without dark there is no light, and vice versa.

Analogous colors are adjacent to each other on the color wheel. Orange, yellow-orange, and red-orange work well together because they are analogous. Explore other color combinations. To find split complements, choose a color, find its opposite on the wheel, then use the colors adjacent to the opposite. For example, if you choose red, whose complement is green, use the colors adjacent to the complement: blue-green and yellow-green.

Break out of your color prejudices. Green may not be your favorite color, but if you choose to work with nature, it is necessary. Yellow may set your teeth on edge, but where daffodils grow, yellow abounds. Be open to using any color that adds to your quilts. Study the color wheel independently or in a class. Understanding color is an important aspect of any visual work.

Another color opportunity to consider is the dead or dying leaf. Even the healthiest plants have leaves that are past their prime. Water- or sun-damaged leaves also appear on most plants. These leaves offer the chance to add another range of colors and values. Rusts, yellows, browns, and golds work wonders. This palette provides just a touch of spice to the vibrant colors used in the rest of a nature-based design. Try adding this element in background leaves for more texture and realism.

Nature offers the perfect palette. Let it be your guide. Teach yourself to look at the world around you. Notice that grass is not just green, but is instead a combination of greens. Observe further that grass is not only green, but also yellow and tan. Notice the trees. The bark is not just brown, but light gray and charcoal as well. Look at gardens. Watch plants as they grow and mature. Notice how light plays off each blossom or leaf by reflecting its color onto other parts of the plant. Do the leaves have touches of red from the peppers reflecting onto them? If you see it in nature, add it to your appliqué. You cannot go wrong.

Setting Fabrics

When you start looking for setting fabrics, let the background fabric and the colors in the blocks be your guides. Take your blocks with you to the quilt shop. Joan Dawson, Laura M. Reinstatler, and I visited In The Beginning in Seattle to look for a setting fabric for Joan's quilt, "Nature's Bounty" on page 46. The oohs and aahs from the staff brought a big crowd to view Joan's beautiful blocks.

Naturally, everyone had a setting fabric suggestion. We finally settled on two possibilities. Being wise, Joan bought both fabrics so she could make the decision at her leisure. Occasionally, what looks good one day looks inappropriate the next. Besides, we all need more fabric. Joan will do something wonderful with her other yardage later.

Working with appliqué quilts is very much like working with scrap quilts. Try to include small-scale, large-scale, geometric, and organic prints. Value is also a consideration in the overall appearance of the quilt. Light, medium, and dark work together to make the setting design appear. If the background fabric is light in value, use dark and medium setting fabrics to draw attention to each element. The opposites are true for background fabrics of other values.

Keep the atmosphere of the appliqué blocks in mind when choosing the setting fabrics. Often a focus fabric starts the process of an appliqué quilt. Use this focus fabric to help you select fabrics for the setting.

The images in the block designs extend beyond the perimeter of the block. To contain this imagery, try using a narrow sashing or separating strip around each block before adding it to the setting. These strips offer another opportunity for adding color and fabric to the setting. Think of them as matting on a picture.

*Light background,
dark and medium setting fabric*

*Dark background,
light and medium setting fabric*

*Medium background,
dark and light setting fabric*

Technical Considerations

Fabrics come in a variety of weaves, patterns, and colors. Consider more than just the look you want when choosing fabrics. Loose-weave fabrics tend to shrink at a different rate than tight-weave fabrics. Prewashing loose-weave fabrics increases their compatibility with other fabrics. But even with prewashing, looser weaves make reverse appliqué almost impossible. For reverse appliqué, choose a fine, closely woven cotton.

I use any fabric that gives me the look I want. Cotton fabrics, however, are easiest to appliqué. Available in a variety of weaves, cotton offers interesting textures for appliqué. Try using cotton sateen, cotton damask, and other weaves along with cotton broadcloth. All cottons work well together.

Whether you prewash fabrics or not is your decision. Consider all the risks. If a fabric discharges its dye, it shows in the washing machine, not on the finished quilt. If the fabric is still suspect after a couple of washings, do not use it. After washing and drying, test the fabric by rubbing it on a small piece of white cloth. If any color shows on the white cloth, the dye is still being released. Another factor to consider is the sizing and finish on the surface of fabrics, which can irritate your hands. Washing removes these chemicals.

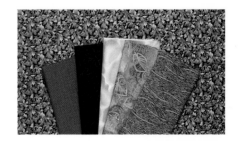

*Focus fabric with other fabrics
for quilt set*

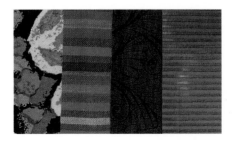

Sample of framing strips

building your QUILT

Each time you make a quilt, you add your touch to it. How many blocks you use, how you set the blocks, and whether you appliqué or piece the borders are all elements of style. Every project develops a voice as you work through it. Listen carefully and follow that voice.

Before beginning your project, draw potential settings on graph paper. Working on paper creates a road map to guide you through the setting process. This map only *suggests* how the quilt might look. Be careful not to fall into the trap of thinking the quilt must look like the drawing.

Make several drawings. Turn some of the blocks on point and others straight. Add appliquéd borders or pieced sections in the interior of the quilt as well as outside the body of the quilt. Make a quilt from borders only. Play with the block and border designs in this book as you would with building blocks. Each sketch will bring another idea to mind.

Asymmetrical borders are one of my favorite design elements. Draw a border on the top only or on the left side only, then see how you feel about this look. A pieced border combined with an appliqué border on one edge might be just what you want. Asymmetrical borders add interest and cut down on time spent appliquéing.

A border used at the top only

Straight and on-point blocks combined

A border section and pieced elements used in the body of the quilt

Appliqué and pieced borders combined

Borders used in the body of the quilt

"Salsa Days" on page 48 uses a border as the major design element. In "Garden Window" on page 52, the border motifs are in the body of the quilt. This bilateral symmetry still gives the feeling of a finished quilt. Experiment, but don't stop with borders. Try using the vertical medallion on page 42 in the body

of a quilt, or trace a repeat of the medallion design to create a border. In "Delicious" on page 54, the vertical medallion is in the middle of the quilt. Imagine it at the right or left or even used alone in panels as the body of the quilt.

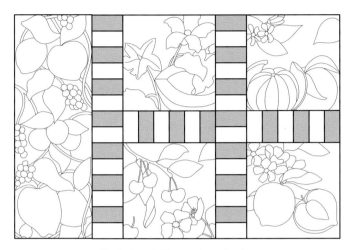

Vertical medallion used as a border

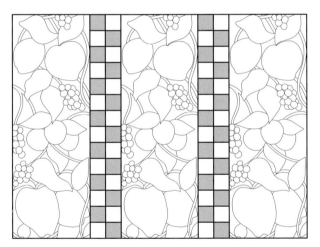

Vertical medallion used in the body of the quilt

Scale

When working on paper, remember to consider scale. The block patterns in this book are 6" x 6" finished. The small block size requires detailed and delicate design work. If set with pieced elements of the wrong scale, the appliqué blocks fade. One-inch finished pieced elements work well. Many of the quilts in the project section include pieced elements of this size.

Design Walls

The only way to know if the fabrics work well together is to view them from a distance. Use a design wall to check your appliqué and to choose setting fabrics. Check each block occasionally as you appliqué. A good time to take a look is after pinning each piece in place. Look for value and color change. Once your appliqué is complete and you have an arrangement that pleases you, try auditioning setting fabrics. If making a wall quilt, view it vertically. If making a bed quilt, view it horizontally (on a bed or table) for proper perspective.

 TIP Foam-core board, available at art- and office-supply stores, makes a perfect temporary design wall. Cover the board with flannel or fleece, then store it until needed.

Next, construct some pieced blocks and put them on the design wall with the appliqué blocks. How do they look? Are the colors working well together? Do the pieced blocks look too large for the appliqué blocks? View your work at each step for the most effective finished product.

gadgets & NECESSITIES

Armed and ready with fabrics and a project in mind, let's begin to appliqué.

Wait . . . halt . . . stop . . . just a minute. What needle will you use? What thread is best for appliqué? The little things make a difference. There are as many choices as there are quiltmakers. Here are some suggestions for gadgets to make your work easier.

NEEDLES

Needles come in different styles for different kinds of sewing. For needle-turn appliqué, try a long needle, like a Sharp or a milliner's needle (size 11 or 12). The long needle aids in turning the seam allowance and keeps your hand just far enough away from your work to prevent fraying. A shorter needle, such as a Between, puts your hand too close to the seam allowance, causing the edges of the fabric to fray while you turn under the seam allowance.

Between ————

Sharp ————

Milliner's ————

 TIP If you are having trouble turning the seam allowance under with the needle, try using a round wooden toothpick. Keep the toothpick in the corner of your mouth until you need it. The damp, rough surface of the toothpick grabs the edge of the fabric, easily rolling under the seam allowance. Ah, the lowly toothpick, now elevated to an important appliqué tool. Don't laugh; it works.

THREAD

One of the goals of appliqué is to hide the stitches. The right kind of thread is the first step to accomplishing this goal. Use 50-weight cotton thread for best results. This weight more closely approximates the threads in fabrics. Match the thread color to the color of the appliqué piece. If you cannot find the exact color, use a darker thread, since thread sews in lighter.

If you cannot match cool colors, use a gray thread of the same value. Notice that some gray threads have a green cast, others a blue, brown, or even violet appearance. Choose the gray that is closest to your fabric.

Machine-embroidery thread is a good second choice. Designed for use in heavy embroidery to cover the edges of machine appliqué, it is finer and less sturdy than the 50-weight. Machine-embroidery thread has a bright surface sheen. Take care to hide your stitches so the sheen is not visible on the finished appliqué.

SCISSORS

Small and sharp to the point, embroidery scissors are an absolute necessity. Larger scissors are difficult to use when trimming from behind or clipping into points and curves.

PINS

Good-quality silk pins are also helpful. Use these fine, thin pins to hold the appliqué shapes in place while basting. Silk pins are available in different lengths and diameters. Look for a long silk pin with a small diameter for the best results. These finer pins slip into fabric and never leave holes.

THIMBLES

If you have never worn a thimble, now is the time to try one. Most quiltmakers wear thimbles for the actual quilting stitch, but do not wear one for other hand sewing. Try a soft thimble for appliqué. Small leather thimbles work well. If you become comfortable with the soft thimble, try a metal one. With time, any type of thimble becomes comfortable.

MARKING TOOLS

Pencils, pens, chalk . . . what to use to mark the fabric?

In needle-turn appliqué, the drawn line is the sewing line. The more accurate this line is, the more accurate the finished work. I use .01mm Pigma™ pens. They produce a fine, highly visible line and move easily across the fabric, allowing you to maintain the integrity of the line with little effort. The ink is permanent, though, so you must work with care. If you cannot bring yourself to try a pen, a fine-lead mechanical pencil is a good alternative.

For dark fabrics, try a silver or white chalk pencil. Keep the pencil well sharpened for a thin, visible line. Blue, red, and yellow chalk pencils often leave residue on the fabric, so use them with caution.

SURFACE-DESIGN TOOLS

New toys that can make a major difference in the look of your appliqué are colored art pencils. These pencils are available from many manufacturers. Be aware: These are not map colors, but artist's colored pencils. Use them to add color or shading to any flower, leaf, or fruit. These pencils are not permanent and cannot be washed. For instructions on how to use them, see page 27.

For pen-and-ink stippling (pages 26–27), .03mm and .05mm Pigma pens work well.

FREEZER PAPER

A must for making master patterns and a good choice for appliqué templates.

GLUE

Two other necessities are a gluestick and a bottle of liquid stop-fray glue. Use the gluestick when seam allowances begin to fray and do not want to turn under. Gently run the needle horizontally through the surface of the stick, not picking up too much glue. Then turn the seam allowance under with the needle. The small amount of glue on the needle grabs the fraying threads and turns them under with the rest of the fabric.

Gently glide the needle through the glue to control frayed edges.

Liquid glue prevents fraying in the inner points of an appliqué shape. For example, the inner point of a heart is often difficult to perfect. Paint the liquid glue outside the drawn line on the inner point of the heart. Allow the glue to dry, then appliqué. The glue keeps any pesky threads from going "boing" at the inner point.

Fabric glue

Liquid glue can discolor certain fabrics; however, this is usually not a problem if you paint only outside the drawn line. Always pretest the glue before using it, just to be sure. If you are painting the glue on an already basted appliqué shape, place an unlined index card between the appliqué and the background fabric. This will keep the glue from leaking onto the background.

final PREPARATIONS

Making a Master Pattern

Full-size patterns for the feature blocks appear in the back of this book (pages 75–111). For ease in sewing, prepare a master pattern of each block. (See page 42 for medallions and page 44 for borders.)

1. Cut a piece of freezer paper at least 8" x 8" for each of the feature blocks.
2. Fold the paper in half, then in half again. (Fold the vertical medallion in half crosswise only.) Unfold and match the center folds to the dotted lines on the pattern.

Fold lines
Fold
Fold

3. Trace the pattern using a fine-lead mechanical pencil. Erase and correct as needed.
4. After completing the tracing, ink the lines with a permanent black felt-tip marker. The ink makes the pattern more visible for tracing onto fabric.

 Master patterns last indefinitely. Store them in plastic protective sheets for future use.

Preparing the Background Blocks

1. Cut background blocks 8" x 8" for feature blocks, 7" x 17" for the vertical medallion, and 14" x 20" for the horizontal medallion. (See page 44 for borders.)
2. Fold the fabric in half and gently press, then fold in half again and press. These fold lines match the fold lines on your master pattern; they serve as placement lines during

Fold
Fold
Fold

the appliqué process. Use the folding technique for all your appliqué patterns and backgrounds.

NOTE | You can also mark center fold lines by stitching along them with a contrasting thread. After completing the block, remove the stitching. Lightly dampen the fold line and press the block with a hot iron to remove any remaining creases.

Window Templates

Before beginning to sew, there is one last step. The feature blocks resemble a cropped photograph; the plant seems to be growing beyond the edges of the block. To view the block correctly as you work, make a 6" x 6" window template. As you sew, place this window over your block. This focuses the image, aiding in color selection. Since the window is the finished size of the block, it also shows how accurately you are following the design.

Poster board of any color works well for window templates. Carefully mark a 6" square on the wrong side of a piece of poster board that is at least 8" x 8". Cut out the square with scissors or a craft knife. (If using scissors, start cutting in the center of the poster board. Cutting in the center first eliminates any ragged edges.) Try using a window template with any appliqué block. It eliminates the distraction of excess background fabric.

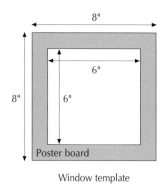

8"
8"
6"
6"
Poster board

Window template

Appliqué block

needle-turn APPLIQUÉ

Appliqué techniques abound. From needle-turn to freezer-paper and even machine appliqué, each of us searches for the technique that is right for us. If you have perfected a technique, there is no need to change. Technique shopping, while fun, doesn't give you the time to perfect one method. If you are a beginner or still have difficulty with the technique you are using, try the following needle-turn directions. For information on a variety of appliqué techniques other than needle-turn, refer to *Botanical Wreaths* by Laura M. Reinstatler.

Marking & Cutting

LIGHT-BOX METHOD

1. Tape the master pattern to your light box, using ¼"-wide masking tape.

2. Turn on the light box. Find the shape numbered 1. Choose a design fabric for this shape and place it on the light box over shape 1. Using the marking tool of your choice, trace the shape onto the fabric. Cut out the shape, adding a ⅛"-wide seam allowance (see Note).

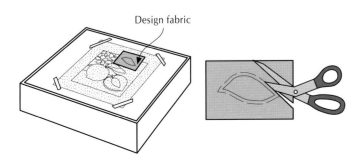

Design fabric

NOTE When cutting, add a full ¼" or more to any edge that will extend into the seam allowance of the block (beyond the 6" x 6" square for feature blocks). Do the same for any piece that will be covered by another. (See "Layering" on page 19.)

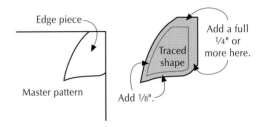

Edge piece · Master pattern · Traced shape · Add a full ¼" or more here. · Add ⅛".

3. Place your background fabric over the master pattern. Match the center fold or stitching line on the fabric to the center line on the pattern. If you need extra security, tape the background fabric in place. Looking through the background fabric to the paper pattern, locate shape 1. Place the cut piece over the lines for shape 1, carefully matching the drawn lines, and pin to the background.

Background fabric · Pattern

4. Baste the shape in place and remove the pin. Go back to the light box and check if the fabric is still in the correct position. If the placement is correct, begin your appliqué.

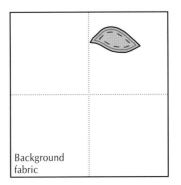

Background fabric

5. After appliquéing each piece, turn the block over to the wrong side. Trim the excess background fabric behind the piece, being sure to leave a full ¼"-wide seam allowance.

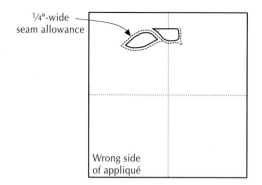

¼"-wide seam allowance

Wrong side of appliqué

Continue to prepare and appliqué each piece *in numerical order* until the block is complete.

NOTE | Never draw on your background fabric unless you are doing reverse appliqué (pages 21–22). Matching the sewn line to the drawn line is almost impossible. When these drawn lines show, they mar the beauty of the work.

TIP | Using a light box allows you to "fussy cut" the design fabric for specific effects. The tomatoes in "Salsa Days" on page 48 came from three fat quarters of hand-painted fabrics. I moved each fabric around on the light box until I had just the right section over the pattern, guaranteeing that each tomato had just the right color and shading.

Consider making or buying a light box to aid your appliqué. If you make your own, be sure to use fluorescent bulbs. Incandescent bulbs strain your eyes too much over the long term.

A clear plastic storage box makes a good light box. Buy two under-the-counter fluorescent fixtures, place the light fixtures inside the plastic box, and voilà, an instant light box!

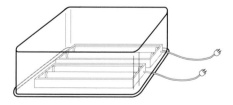

TEMPLATE METHOD

Working with a light box eliminates the need for templates, since you transfer the design directly to the fabric. This method cuts down on preparation time, but it can take some getting used to. If you prefer to work with templates, try using freezer paper.

Freezer paper is easier to cut than template plastic, so intricate shapes stay accurate.

1. Place the freezer paper over the pattern shape, shiny side down, and trace each piece's exact outline.

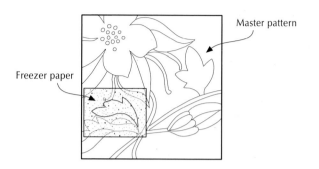

Master pattern

Freezer paper

2. Cut out the freezer-paper template on the traced outline. Do not add seam allowances. For all appliqué, the drawn line is the turn-under line. Add the seam allowances when cutting the shape from fabric.

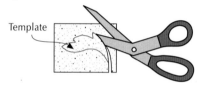

Template

3. Place the freezer paper on the *right* side of the design fabric, shiny side toward the fabric. With a dry iron on the cotton setting, press the freezer-paper template onto the design fabric. When heated, the waxy backing on the paper melts slightly, adhering to the fabric.

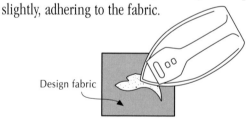

Design fabric

4. Trace the shape onto the design fabric by drawing around the edge of the paper template. Peel off the template.

5. Cut out the fabric piece, adding a ⅛"-wide seam allowance. (See Note on page 15.) Position the piece on the background fabric and appliqué in place.

Stitching

If you are new to appliqué or feel your appliqué skills need improvement, practice by following these directions for appliquéing a needle-turned leaf. All the shapes found in appliqué appear in this leaf. Continue to practice with this shape until you feel comfortable.

1. Trace the leaf template below onto the uncoated side of a piece of freezer paper. Do not add seam allowances while drawing the leaf. Place the tracing on a light box. Choose a design fabric for the leaf. Turn on the light box and place the design fabric, right side up, over the leaf shape. Trace the leaf onto the fabric. Cut out the leaf, adding a ⅛"-wide seam allowance.

Leaf template

NOTE | If you do not have a light box, refer to the steps 1–4 on page 16. Cut out the freezer-paper shape along the drawn line to make a template. Do not add seam allowances while drawing or cutting.

2. Cut out a 5" x 5" square of background fabric. Fold the square in half, press, then fold in half again and press to mark the center. (This step will be important later when working from a master pattern.) Use the creases as placement lines for the leaf.

Background fabric

3. Cut out the leaf, adding a ⅛"-wide seam allowance. In most needle-turn appliqué, smaller seam allowances make turning easier.

Cut out leaf, adding ⅛"-wide seam allowance.

4. Fold the leaf in half and finger-press, then fold in half again and finger-press. Match the fold lines on the leaf to the fold lines on the background fabric. Pin in place.

5. Cut a 12" to 18" length of thread. Thread the cut end through the eye of the needle, pull it through, and knot it. Threading the needle in this manner prevents the thread from knotting and twisting while you appliqué.

Cut thread.
Insert and knot this end.

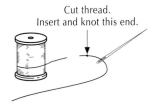

6. Baste the leaf to the background fabric, sewing ½" inside the drawn line.

7. Start appliquéing along the straightest edge possible, for example, the right side of the leaf just above the bottom point.

Start here.

8. Roll the seam allowance under to the drawn line so the line is no longer visible. Hold the turned portion in place with your thumb.

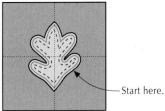

Needle-turn appliqué (right-handed quilter)

9. Bring the needle up through all the layers (the background fabric and the folded edge of the leaf). Pretend you are slipping the needle through the fold created by turning under the seam allowance. Notice that the folded seam allowance is at the bottom of the work. Sewing toward yourself allows you to see the folded edge and stitches better.

Stitch from top to bottom or right to left (left to right for left handers).

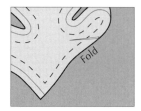

10. Find the spot where the thread came out of the leaf. Insert the needle tip slightly behind that thread and into the background fabric as close to the leaf as possible without stitching through it. Push the needle forward, bringing the needle tip up through the background and the fold line of the leaf.

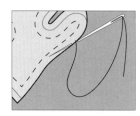

11. Continue, inserting the needle into the background just behind the last point where the thread came out, then up through the leaf. Whenever necessary, stop and use the needle to turn under more of the seam allowance. Never sew beyond your thumb; it hides bumps and bubbles that change the appliqué line. Stop before you reach your thumb, and turn under another portion of the seam allowance.

12. As you stitch, keep the needle as parallel as possible to the edge of the leaf. Inserting the needle parallel, not perpendicular, to the folded edge hides the stitches.

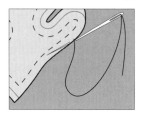 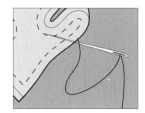

Correct Incorrect

13. Stitch to the point of the leaf and take the last stitch at the end of the drawn line. The seam allowance you just turned under fills the space where the point lies. Slip the tip of your scissors under the leaf and trim only the excess seam allowance under the point of the leaf. This is not the seam allowance for the next side, but the seam allowance for the side already sewn.

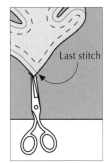

Last stitch

14. Turn the appliqué so the point of the leaf is facing away from you. Fold the seam allowance under as shown. If there is too much seam allowance to fit under the point, carefully trim under the point again.

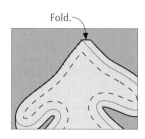

Fold.

15. Take a stitch right at the point and give the thread a gentle tug before starting on the other side of the leaf. Hold the point down with your thumb while tugging on the thread to keep the seam allowance in place. This should pull the point back into shape if it became blunted. Roll under the seam allowance and continue to appliqué.

16. At the curve of the leaf, stitch slowly. The key to a smooth, round curve is to turn and stitch, turn and stitch. Needle-turn only a small portion of the seam allowance at a time, and remember to avoid sewing beyond your thumb.

17. Stitch toward the concave curve of the leaf until the seam allowance is difficult to turn. Never clip curves or inner points until you reach them. This reduces fraying in the seam allowance. Concave curves can be gentle S-curves or sharp dips. On the S-curves, small seam allowances are usually sufficient for turning. If you need to, clip to the drawn line in very few places to release the fabric. On a sharp concave curve, such as the curve of the leaf, it is necessary to clip to the drawn line in at least 3 places to release the seam allowance. After clipping to the line, sweep the entire seam allowance under at one time. Pull the seam allowance toward you to ease in the fabric. The more acute the curve, the more clipping required. Try to leave some space between the clips, ⅛" when possible. Make your clips where the curve starts and where it is most acute.

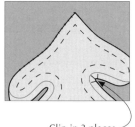 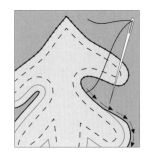

Clip in 3 places.

18. Continue to appliqué until you reach the inner point of the leaf (the "inny"). Clip the inny when you are close enough to it that the seam allowance no longer turns under.

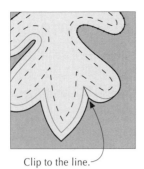

Clip to the line.

19. Turn under the remaining seam allowance all the way to the cut. Appliqué to the middle. Take a stitch exactly at the point. Turn under the seam allowance on the other side of the point and continue to appliqué.

Turn under remaining
seam allowance to the cut.

The 3 center stitches in the inner point create an inverted V, with 1 stitch to the right of the point, 1 in the center, and 1 to the left.

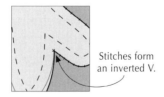

Stitches form
an inverted V.

20. Continue appliquéing until you reach the spot where you started, then take a few stitches beyond this point.

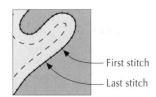

First stitch

Last stitch

21. Push the needle through to the back. Take a small "bite" of fabric, ⅛" from the stitching line, and tie a knot. Slip the needle under the background fabric and travel a small distance from the knot. Bring the needle out and cut the thread. This keeps the knot and loose end from showing through the background fabric.

Wrong side

Knot thread
⅛" from edge.

22. Carefully slit the background fabric behind the appliqué piece, then trim it away, leaving a ¼"-wide seam allowance.

Layering

In appliqué, layering occurs when one design element falls across another. When this appears in a block design, it is important to extend the bottom shape a full ¼" under the shape on top. This prevents any raw edges from showing on the finished work. There is no need to appliqué these edges.

Pressing

After appliquéing each shape, use your fingernail, a chopstick, or the color-coded end of a Pigma pen to finger-press the edges. Start by gently pushing the fabric from the center toward the edge. Always move from the center outward. Avoid pressing upward on the edge since this causes the fabric to wrinkle.

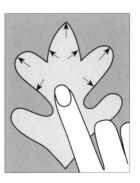 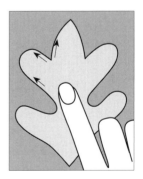

Finger-press from the center
of the appliqué shape toward
the edge. Roll excess fabric
over the sewn edge.

Avoid pressing upward
on the sewn edge,
which can cause wrinkles.

Finger pressing pushes any excess fabric over the sewn edge, hiding the stitches and making the shape flatter and smoother. When you are ready to press with an iron, the finger pressing will still be in place. Try finger-pressing a shape and you'll see—some of the most visible stitches disappear immediately.

Troubleshooting

Listed below are some common problems that occur in hand appliqué and suggestions for correcting them.

 THE STITCHES SHOW

- Make sure the thread color matches the appliqué fabric.
- Make sure the thread isn't going into the background fabric too far from the appliqué or coming out too far inside the appliqué as you stitch.

Stitching too far into the background

Stitching too far into the appliqué fabric

- Make sure your needle is moving parallel, not perpendicular, to the fold. (See page 18.)
- Check your tension. If it is too loose, pull the thread a little tighter.

 THE DRAWN LINE IS VISIBLE

- Roll more of the seam allowance under the leaf, completely hiding the drawn line.
- Decrease the size of the seam allowance in order to fit the entire line under the leaf.

problem **3** **THE CURVES ARE LUMPY, NOT SMOOTH**

- Your seam allowance may be too wide. Trim the seam allowance slightly and try again.
- Your stitches may be too far apart or too large. Use smaller, more closely spaced stitches.

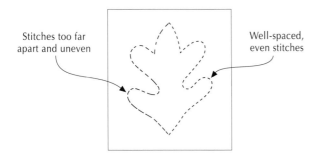

Stitches too far apart and uneven

Well-spaced, even stitches

- You may be stitching beyond your thumb. Stop sewing before you get to the section under your thumb.

problem **4** **THE CONCAVE CURVES ARE NOT SMOOTH**

- Make sure to clip in the proper places to release the seam allowance.
- Turn under the entire seam allowance on the curve at one time, using a sweeping motion.
- Pull the seam allowance toward you; don't push the seam allowance under. Pulling the seam allowance as you needle-turn eases the fabric away from the previously sewn edge.

problem **5** **THE POINTS ARE NOT SHARP**

- Trim excess seam allowance. Remember, you have only a small space under which to get all the seam allowance. Too much fabric in the seam allowance creates a bulge.
- Gently tug on the thread after taking the stitch right at the point. Be sure to hold the point with your thumb. These steps pull the point back into shape.

problem **6** **THE APPLIQUÉ IS LOOSE AND PULLS AWAY FROM THE BACKGROUND FABRIC**

- Your tension is too loose. It is better to pull the stitches a little too tight and correct it when pressing than to make the stitching too loose and risk losing an appliquéd piece. To maintain even tension when hand sewing, draw the thread through with your little finger. (Using a wrist motion to pull the thread through makes the tension either too tight or too loose.)

Draw thread through with your little finger for perfect hand-sewing tension.

problem **7** **THE FABRIC KEEPS FRAYING AT THE INNER POINTS**

- Be sure to turn the first side of the seam allowance completely to the point before stitching.
- Try painting a little liquid glue outside the drawn line. (See page 13.)

special TECHNIQUES

Included in this section are more appliqué techniques, plus several fun techniques that may be new to you. Practice them all until you feel comfortable with them.

Turned Leaves & Petals

The turned-leaf technique is an approach to design that visually splits a leaf into two or more parts. It makes the underside of a leaf or petal appear to turn up and over the top side.

This is not a sewing technique, but a value or color technique. A strong value change brings dimension to the turned portion of the design. The Comfrey block on page 38 is a good example. Without the value change, the leaves would appear flat. With the value change, the leaves twist from back to front, just as a real plant grows. Notice also the Beets block on page 34. The drama of this block comes from the color change in the leaves.

Turned leaves and petals appear in several of the patterns in this book. Follow the numerical order when appliquéing to create the most dimension. A strong value or color change is the key.

Reverse Appliqué

Delicate stems, the insides of tiny pea pods, and many other shapes call for reverse appliqué. Reverse appliqué works best with a fine, tightly woven fabric, preferably cotton.

Reverse appliqué adds another dimension to any appliqué project. In direct appliqué, the design fabric adds to the surface dimension. The design moves toward the viewer. In reverse appliqué, the design fabric lies under the background fabric, so it appears to recede from the viewer. Use both reverse and direct appliqué as appropriate for the maximum effect.

Notice the open pea pods in the Sugar Pea block above. The inner part of the pod is an example of reverse appliqué.

To reverse-appliqué a pea pod:

1. Trace the pea pods onto the right side of the outer pod fabric. Draw both pea pods at the same time. Be sure to leave space between the pods for seam allowances. Number each piece in the seam allowance for easy reference.

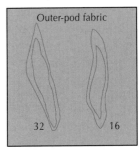

Prepare fabric for reverse appliqué by drawing pea pod onto the right side of the fabric.

2. Cut a piece of inner-pod fabric large enough to extend entirely under the outer pods. Pin the fabric into place behind the outer-pod fabric, right sides up.

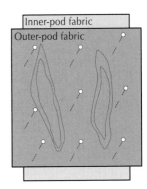

3. Baste ¼" outside the outer drawn lines as shown.
4. Cut the outer-pod fabric inside the inner drawn line, leaving a ⅛"-wide seam allowance. To prevent fraying, cut only 1" at a time.

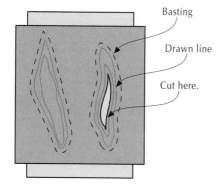

5. Appliqué, stopping to cut when necessary.
6. Finish the line of stitching for reverse appliqué the same way you would for direct appliqué. On the back, remove the excess inner-pod fabric by cutting ¼" from the stitching. Repeat for the next pea pod.

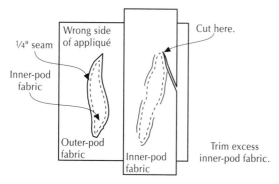

The illustrations and instructions below are for reverse appliquéing a stem into the background fabric of a block. Study them carefully before practicing this type of reverse appliqué.

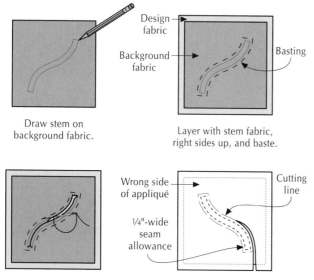

Draw stem on background fabric.

Layer with stem fabric, right sides up, and baste.

Cut along center a few inches at a time and appliqué both sides.

Trim excess stem fabric.

Cut-to-Shape Appliqué

Use this technique for stems, branches, and vines. Cutting to shape gives a more natural appearance and narrower shape than using straight bias tubes.

1. Trace the exact shape of the stem onto the right side of the design fabric.
2. Cut out the stem, adding a ⅛"-wide seam allowance.

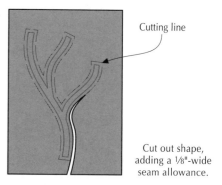

3. Pin the stem to the background fabric and baste a single line down the middle, inside the drawn lines. For very thin stems, baste in the seam allowance opposite the side where you will begin your appliqué.

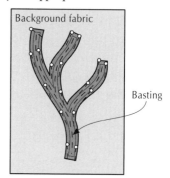

4. Appliqué one side of the stem. Remove the basting. Fold the stem back to reveal the seam allowance. Trim the seam allowance as close as possible to the stitching.

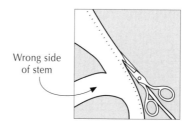

5. Return the stem to its proper position and baste again. (If the stem is very narrow, rebasting is not necessary.)
6. Complete the appliqué. Do not trim the background behind the stems unless you can leave a full ¼"-wide seam allowance on each side.

If the stem isn't curved, cut out the shape on the bias of the fabric. This ensures that the stem will lie flat when appliquéd.

Little Teeny Round Things

It's the little things that count, in life and in appliqué. Amaze your friends with your new-found skills. Show off all those currants, peas, and flower centers when you finish each block. Don't worry if they're not all perfectly round. Organic shapes often are slightly oval or smushed in on one side.

CIRCLES

This is a no-fail technique for making perfect berries or circles of any kind.

1. Using a circle template or any circular object of the desired size, draw the finished-size circle onto an *unlined* index card. Cut out on the drawn line. Do not add seam allowances. Be sure to use your paper scissors. (A ¼" hole punch is perfect for teeny circles. I pay my twelve-year-old son a dollar a card to punch circles for me.)

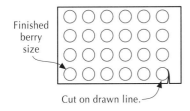

Finished berry size

Cut on drawn line.

Office-supply and print shops are excellent sources for unlined card stock. They carry a variety of weights in 8½" x 11" sheets for a few cents each.

2. Cut out fabric circles for each circle template, adding a full ¼"-wide seam allowance. With a single thread knotted at one end, sew a line of small running stitches just inside the cut edge on the right side of the fabric circle. Do not sew past the knot.

Right side of fabric

3. Place the paper circle inside the fabric circle on the wrong side of the fabric. Gather the running stitches around the paper for perfect circles every time.

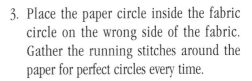

Paper circle

If small bumps appear on the edge of the circle, turn the circle to the back side. Run the needle through one bump, move to the opposite side of the circle, and run the needle through another bump. Gently tug on the thread as you continue to weave. This weaving eases in the excess fabric that causes lumpy edges.

4. Knot the thread, and you are ready to apply the circle. Pin in place and appliqué the folded edge as you would a needle-turned edge. Anyone who makes Yo-yos is familiar with this technique. The only differences are the addition of the index card to maintain the circular shape and not needing to fold under a hem.

REMOVING THE INDEX CARDS

Your circles are perfect, but what about the index card trapped inside? If the circle is smaller than 1" in diameter, leave the card inside. Remember, unless you can leave a full ¼"-wide seam allowance, do not trim from behind.

However, if your circle is larger than 1" in diameter, follow these directions:

1. Turn the appliqué block over and make a small slit in the center of the background fabric behind the circle. Insert the scissors tip at the slit and trim the background fabric, leaving a ¼"-wide seam allowance.

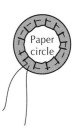

¼"-wide seam allowance

2. With a pair of tweezers or needle-nose pliers, remove the index card. If you have woven threads across the back of the circle, carefully clip the threads before removing the card.

NEEDLE-TURNED ORGANIC SHAPES

Most of the flower centers, berries, and seeds in the blocks are irregularly shaped to resemble nature. They are easy to needle-turn—do not be daunted by their size. Remember, there is an inside and an outside to a drawn line. To enlarge the shapes slightly, draw your sewing line on the outside of the pattern line. This increases the size of the shape slightly, making it more comfortable to appliqué.

The instructions below use the seed shape from the Bell Pepper block. Use the same technique on the currants, sugar peas, and any other small circle.

The key to needle turning any small oval or round shape is to turn and stitch, turn and stitch. Use as little seam allowance as possible on the smaller shapes since there is not much room under the shape.

1. Trace the shape onto your design fabric. Cut out, adding a ⅛"-wide seam allowance.
2. Using the master pattern, place the seed in its proper position and pin in place.
3. To baste a shape of this size, take a single stitch in the center of the shape, then backstitch through the first stitch. This should hold the piece securely. If the shape is large enough, stitch an **X** in the center to baste. It is tempting to pin rather than baste shapes this small. Resist the temptation.

4. Find the straightest edge possible to begin your appliqué. On the seeds, there is a straight side just below the top curve. Appliqué the seed with small, close stitches. Do not trim behind shapes this small.

To appliqué berries or peas, follow all the steps above. "But there are no straight sides on small circles. Where do I start?" To prevent misshapen circles, start by needle turning a portion of the seam allowance, as you would for any appliqué piece. Do not start sewing yet. Turn under another portion of the seam allowance, even if the first portion pops out again. Turning under this second section gives you a feel

for the circle. You begin to see the line of the curve better. Now, appliqué the second section.

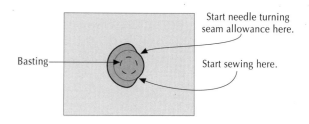

Remember, the key to needle-turned ovals and circles is turn and stitch, turn and stitch, with small, close stitches.

Preconstruction

Preconstruction involves appliquéing shapes to each other before applying them to the background block. Building before applying is one of my favorite techniques. I preconstruct vein lines, turned leaves, and even larger units. Read the step-by-step directions for each block to find out when to use this technique.

TURNED LEAVES

The following directions are for a leaf in the Borage block.
1. Trace leaf 7 onto the design fabric. Trace only the section that will be appliquéd to the background, in this case the lower edge.

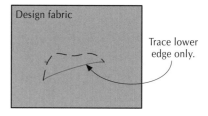

2. Trace leaf 8 onto a second design fabric. Trace the complete shape for this piece. Cut out the shape, adding a ⅛"-wide seam allowance.

3. Using your light box for proper placement, baste leaf 8 in place over leaf 7. Appliqué only the line joining the two pieces as shown.

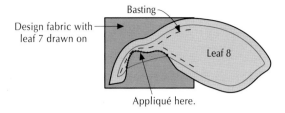

4. Turn the piece over and cut away the leaf 7 fabric under leaf 8 along the line of stitches, leaving a ¼"-wide seam allowance.

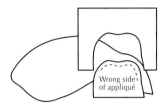

Remove basting and trim excess fabric.

5. Return to the front and cut out the lower edge of leaf 7, leaving a ⅛"-wide seam allowance. Place the leaf in position on the background block and appliqué.

Cut out with ⅛"-wide seam allowance.

Look through the other patterns. Notice the turned leaves in the Bell Peppers block on page 36. Leaf 2/3 is a perfect candidate for preconstruction. In the Oranges block on page 31, leaf 24/25 cries out for preconstruction. Remember to read the instructions that accompany each block for preconstruction suggestions.

VEIN LINES

The vein lines in the basil leaves on page 40 are reverse appliquéd using the preconstruction technique. Reverse appliqué adds dimension, and preconstruction enables you to appliqué the teeny lines with ease.

1. Draw the leaf onto the design fabric. If you want to make more than 1 leaf from this fabric, be sure to leave enough space between the leaves for a seam allowance. Number each leaf in its seam allowance to prevent confusion later.
2. Place the leaves on a square of fabric you have chosen for the vein. Baste outside the drawn lines around each vein. Cut down the center of the channel created by the drawn

lines and begin your appliqué, referring to "Reverse Appliqué" on pages 21–22. Remember to cut only 1" at a time.

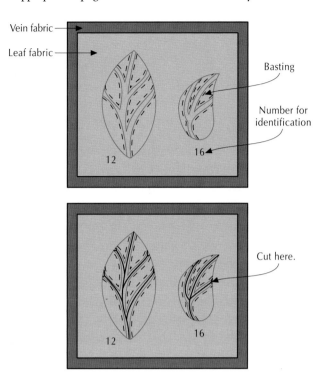

3. When finished, remove basting, turn the fabric over, and cut away the vein fabric, leaving ¼"-wide seam allowances. Place the leaf in position on the block and appliqué.

COMPLETE UNITS

Entire units can be preconstructed before appliquéing. Look for units without sharp curves or corners on the outside perimeter. Bulky seam allowances at curves and points are difficult to appliqué. Any unit free of sharp curves or points is easily preconstructed, then appliquéd.

The following directions are for the cross-section lemon 31–38 in the Lemons block on page 32.

1. Choose a design fabric for lemon pith 31. Trace the sewing line onto design fabric and cut out, adding a ⅛"-wide seam allowance.

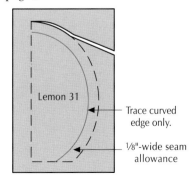

2. Select a fabric for lemon peel 33. Trace the curved edge onto the fabric.

3. Baste piece 31 onto piece 33 and appliqué in place along the curved edge.

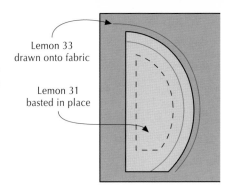

Lemon 33 drawn onto fabric

Lemon 31 basted in place

4. Turn to the back of the appliqué. Trim lemon peel 33 inside the line of stitches, leaving a ¼"-wide seam allowance. On the front, cut out the completed appliqué section ⅛" outside the traced sewing line of lemon peel 33. (Leave a full ¼" along the left side where the appliqué extends into the seam allowance of the finished block.)

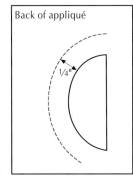

Back of appliqué

¼"

Cut out, leaving a ¼"-wide seam allowance.

5. Choose a fabric for lemon rind 32. Trace the curved edge onto this fabric. Position, baste, and appliqué unit 31/33. Repeat step 4 to trim the rind fabric.

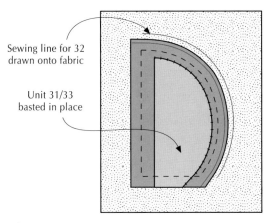

Sewing line for 32 drawn onto fabric

Unit 31/33 basted in place

6. Appliqué lemon sections 34–38 in sequence. Position the finished lemon slice on the background block and appliqué in place.

Appliqué lemon sections into place.

Pens, Pencils & Paint

There are many ways to add detail to your work, and some of them involve tools not usually associated with appliqué. The next three techniques are fun, fast, and easy. Try any or all of them; they make a visible difference.

PEN-AND-INK STIPPLING

Stippling is one of the most widely used techniques in this book. For stippling, use permanent-ink Pigma™ pens, available in a variety of colors and point sizes. My favorite is the black pen with a .03mm point. It provides the maximum effect with the minimum effort. Use colored Pigma pens for a more blended look. There's nothing to stop you using both for double the effect.

SUGGESTIONS

- Stipple after all the appliqué is complete for more accurate shading.
- Start by placing small dots along the edges of each piece.
- Hold the pen upright at a 90° angle to your work surface. If you hold the pen as you would to write, you get small dashes, not dots.

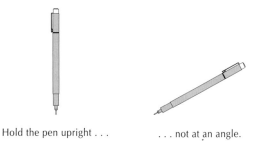

Hold the pen upright not at an angle.

- Stippling only the edges occasionally adds enough dimension to bring flowers and leaves into focus. Try additional stippling where elements cross over one another.
- Many closely spaced dots create dark shading; fewer, widely spaced dots create light shading.

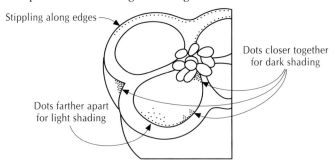

Stippling along edges

Dots closer together for dark shading

Dots farther apart for light shading

- Practice before stippling the finished appliqué. Trace the individual flower or use the master pattern of the entire block. Using your permanent-ink pen, stipple as desired. Refer to

the paper plan when stippling the appliqué pieces.

- For the best results, heat set the stippling when completed.

The visual difference is amazing. Remember to view the blocks from a distance. Place an unstippled block on the wall beside a stippled one. The dots may not be visible from a distance, but the texture produced by the stippling is easy to see.

PENCIL SHADING

One of the new techniques in this book is pencil shading. With pencil shading, solid-color fabric can now have touches of many colors. (The red-violet in the Sugar Peas block on page 57 is all pencil shading.) Use any good-quality colored artist's pencil. These pencils are soft, unlike the hard lead in map pencils.

If you are uncomfortable using this technique directly on the block, try adding the color before you appliqué. This allows you to see the results before sewing.

Pencil shading often disappears if the quilt is washed, but it's easy to replace.

1. After completing the appliqué, look for sections that need a touch of color.
2. Sharpen the pencil to a fine point and apply the color. Take care when coloring on the edge of the appliqué. The needle-turned edge takes the color darker because of the fold.

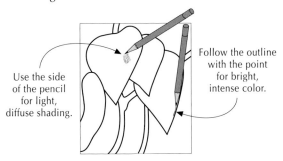

Use the side of the pencil for light, diffuse shading.

Follow the outline with the point for bright, intense color.

3. After shading, gently rub the pencil coloring with a finger to blend.

4. Heat set with a warm iron to prevent further blending or smudging.

FABRIC PAINT

When you're pressed for time, try painting the patterns. Fabric paints are available at most craft stores or by mail order from various suppliers. Tulip™, Deka®, and Createx™ brands all work well. For the best results, avoid dimensional or puff paint.

Light background fabrics work best for painted projects. Experiment on each fabric to see if the paint covers well.

1. Prepare a master pattern following the directions on page 14.
2. Prepare a background block following the directions on page 14.
3. Tape the master pattern to a light box or window. Carefully position the background block in place over the master pattern and tape it in place.
4. Trace the pattern onto the background block using a .01mm or .03mm black Pigma pen. These lines are permanent, so take care.
5. Remove the background block and press to set the ink.
6. Securely tape the background block to a piece of stiff cardboard. (The fabric should move as little as possible during painting.)

7. Paint the background elements first.

8. After painting all the background elements, blend colors directly on the fabric while the paint is still wet. For example, add a touch of yellow or red to a background leaf by lightly brushing a small dab of paint onto the leaf. Fabric paint dries quickly, so blending paints while they are wet works best.
9. Allow the background paint to dry.
10. Begin painting the foreground elements. Paint the large elements first, allowing them to dry for a while before painting the small elements.

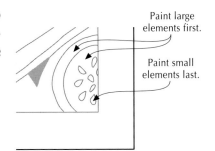

Paint large elements first.

Paint small elements last.

11. Dry the completed block overnight. Heat set, following the manufacturer's instructions.

SUGGESTIONS

- Try combining pen-and-ink stippling with paint. Stippling adds just as much to a painted block as it does to an appliqué block.
- Painting the entire block is fast and easy, but you can also add painted touches to an appliquéd block. In "Summer's Bounty" (page 55), Helen Ruth Brandhurst added paint to blossoms and other elements for additional color. To paint a blossom, shade from the center out with a single brush stroke, pressing down on the brush at the center of the blossom and lifting gently as you move outward.

- Add dots of paint to blossom centers.

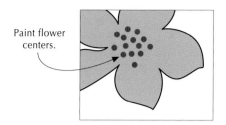

Paint flower centers.

- Is something missing from a tomato or peach? A single stroke of color can make all the difference.

squaring UP

Square up each appliquéd block, medallion, and/or border before assembling the quilt. Carefully press each appliquéd element before cutting the block to the proper size. The fruit, vegetable, and herb blocks are 6" x 6" finished, the horizontal medallion is 12" x 18", and the vertical medallion is 5" x 15".

Keep the grain lines in mind when squaring up the blocks. To prevent puckering and stretching during construction, avoid any bias edges.

1. Find the center of a square ruler (6½" x 6½" is ideal for feature blocks) and place it over the center of the block. Align the ruler so the appliqué fits attractively within the finished dimensions. Remember the ¼"-wide seam allowance required on the edge pieces.

2. Mark the cutting lines with a pencil, remove the ruler, and visually check where the design falls before cutting. If the design fills the space evenly, cut the block along the marked lines. If not, reposition.

3. To cut, place the ruler back in position over the drawn lines. Use a rotary cutter to trim the excess background. Guide the rotary cutter carefully along the edges of the ruler. Rotary cutters produce cleaner, straighter edges than scissors.

TIP If you can't find a 6½" x 6½" ruler, make a template from plastic with the center lines marked. Make additional templates for squaring any odd-size elements, such as medallions. Follow the directions, using the template instead of a ruler.

feature BLOCKS, MEDALLIONS & BORDERS

The blocks in this book are a continuation of my love for floral appliqué. Each block includes many parts of the particular plant. As mentioned earlier, the designs are cropped, the imagery extending to the edge of the block. All edge pieces need ¼"-wide seam allowances along the outside edges.

If some of the elements look too small for appliqué, use embellishments such as beading or embroidery. Painting and pen-and-ink techniques also work well for details. The goal is beautiful work, no matter how you get it done.

Color is the key to stunning appliqué. Use it freely, even wildly. Unlike skirts and blouses, the blocks are not going to be on your body, moving in space. They are static and two-dimensional; they need all the help they can get to come to life. Overmatching colors and fabrics creates dull, lifeless blocks. Exciting color is the magic wand that brings the blocks to life.

A color photograph accompanies each pattern, along with step-by-step directions and a list of suggested techniques with page references. Read through the techniques and suggestions before beginning your appliqué. The feature blocks are 6" x 6" finished (6½" x 6½" cut). Remember to cut your background squares 2" larger than the finished size of the block (8" x 8").

For your convenience, the feature blocks appear in order of difficulty. Pattern 1 in the fruit section is the simplest fruit block; pattern 1 in the herb section is the simplest, and so on. Keep this in mind as you select feature blocks for your project.

pattern 1 M E L O N

pattern 2 P E A C H E S

Melons of any type remind me of summer picnics. This melon is a cantaloupe. If you want to depict a honeydew or other type of melon, adjust the colors accordingly. Use value changes within the cut melon sections to create the illusion of depth.

Use the pattern on page 90. Prepare the master pattern following the instructions on page 14. For the skinny stems, use the cut-to-shape technique on pages 22–23. Refer to page 21 for the turned leaves.

1. Prepare the background block as described on page 14.
2. Appliqué stem 1 in place.
3. Appliqué leaf 2*.
4. Preconstruct center 4 to blossom 3. Appliqué to the block.
5. Appliqué stems 5 and 6.
6. Appliqué melon blossoms 7, 8*, 9, 10*, and 11–13.
7. Appliqué bud 14*/15.
8. Baste inner melon section 16* in place with a single unknotted thread. Since sections 18 and 19 fall over this piece, there is no need to appliqué it.
9. Appliqué melon rind 17*.
10. Appliqué melon sections 18 and 19*.
11. Appliqué turned leaf 20/21*.
12. Appliqué leaf 22.
13. Embroider, ink, or pencil-shade petal lines on blossom 3.
14. Ink blossom center 13.

Extend this piece at least ¹/₄" past the edge of the finished block.

Just imagine biting into a fresh, juicy peach. Nothing is quite like that sensation. This block relies entirely on two colors. Use a variety of greens and oranges for the best results.

Use the pattern on page 93. Prepare the master pattern following the directions on page 14. For the skinny stem, use the cut-to-shape technique on pages 22–23. Refer to page 21 for the turned leaves.

1. Prepare the background block as described on page 14.
2. Appliqué turned leaf 1*/2*.
3. Appliqué petals 3*, 4, 5*, 6, and 7*, and center 8.
4. Appliqué flower 9–12 and center 13.
5. Appliqué flower 14–18. Petal 16 is the back of petal 17; be sure to change values.
6. Appliqué flower 19–23 and center 24.
7. Appliqué turned leaf 25/26.
8. Appliqué leaf 27.
9. Appliqué turned leaf 28/29*.
10. Appliqué whole peach 30.
11. Appliqué peach peel 31.
12. Appliqué peach flesh 32.
13. Appliqué or embroider stem 33.
14. Appliqué peach pit 34.
15. Stipple and/or pencil shade as desired.

Extend this piece at least ¹/₄" past the edge of the finished block.

pattern 3 CHERRIES

pattern 4 ORANGES

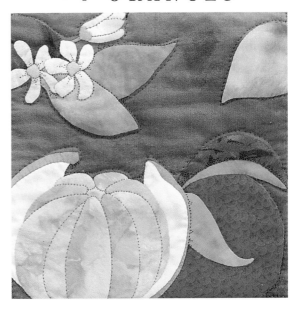

Use the pattern on page 80. Prepare the master pattern following the instructions on page 14. For the skinny stems, use the cut-to-shape technique on pages 22–23. Refer to page 21 for the turned leaf.

1. Prepare the background block as described on page 14.
2. Appliqué leaf 1*. Appliqué leaves 2 and 3.
3. Appliqué stems 4 and 5. If you prefer, embroider or paint these stems.
4. Appliqué cherries 6 and 7. Use different values or colors.
5. Appliqué turned leaf 8/9. Appliqué leaves 10 and 11*.
6. Appliqué, embroider, or paint cherry stems 12 and 13.
7. Appliqué cherries 14 and 15.
8. Appliqué cherry branch 16*. To match the branch to the stems, trace piece 16 along the outside of the drawn line on the master pattern. This will give you enough leeway to fudge the joins.
9. Appliqué leaves 17* and 18*. Leave a section of leaf 18 open as indicated on the pattern.
10. Appliqué cherry blossom stem 19*. Appliqué the open section on leaf 18.
11. Appliqué petals 20–22 and center 23.
12. Appliqué turned petal 24. Remember to make a value change to show the back of the petal.
13. Appliqué petals 25, 26*, 27, 28, and 29*. Appliqué center 30.
14. Appliqué or embroider stem 31 and cherry 32*.
15. Ink or embellish the flower centers. Stipple and/or pencil shade as desired.

Extend this piece at least ¼" past the edge of the finished block.

There is an amazing variety of oranges. Each has a slightly different shade of blossom. Look for the variety that speaks to you when choosing colors.

Use the pattern on page 92. Prepare the master pattern following the directions on page 14. For the skinny stem, use the cut-to-shape technique on pages 22–23. Refer to page 21 for the turned leaf.

1. Prepare the background block as described on page 14.
2. Appliqué leaf 1*.
3. Appliqué blossom stem 2 using the cut-to-shape technique.
4. Appliqué leaves 3–5*.
5. Appliqué petals 6–9*. Petal 6 is the inside of the blossom; petals 7–9 are the back of the blossom.
6. Appliqué calyx 10.
7. Appliqué petals 11–15* and center 16.
8. Appliqué petals 17–21 and center 22.
9. Appliqué whole orange 23*.
10. Appliqué turned leaf 24/25, then single leaf 26.
11. Appliqué outer peel 27* and inner peel 28.
12. Appliqué inner peel 29* and outer peel 30*.
13. Baste orange pith section 31 and orange section 32* using a single unknotted piece of thread. Since the other orange sections cover all the edges of these pieces, there is no need to appliqué them.
14. Appliqué orange sections 33, 34, 35, 36*, 37, 38*, 39*, and 40*.
15. Use colored artist's pencils to add a hint of reflected color in the inner orange peel. Stipple as desired.

Extend this piece at least ¼" past the edge of the finished block.

pattern 5 KUMQUATS

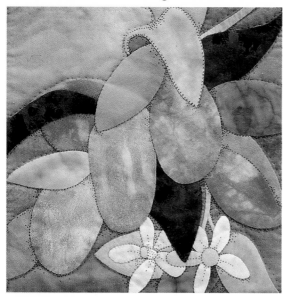

pattern 6 LEMONS

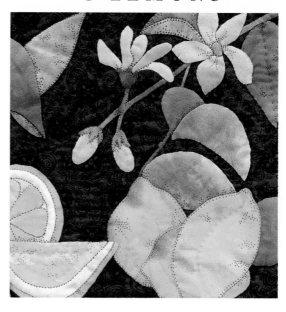

Kumquats are a delightful, tart fruit. If you have never had the opportunity to try them, look for kumquats in Asian markets. The peel is a brilliant red orange, a great complement to the lustrous green leaves.

Use the pattern on page 87. Prepare the master pattern following the instructions on page 14. Use the cut-to-shape technique on pages 22–23 for the branch and stem.

1. Prepare the background block as described on page 14.
2. Appliqué leaf 1*.
3. Appliqué branch 2*. For straight branches or stems, cut along the bias of the fabric. This helps the pieces lie flat with no puckering.
4. Appliqué leaves 3* and 4* and kumquat 5*.
5. Appliqué stem 6.
6. Appliqué kumquat 7*.
7. Appliqué leaves 8, 9*, and 10*.
8. Appliqué petals 11–13, 14*, and 15 and center 16/17.
9. Appliqué petals 18, 19, 20*, 21, and 22 and center 23.
10. Appliqué leaf 24*.
11. Appliqué kumquat 25.
12. Appliqué leaf 26.
13. Appliqué kumquat 27.
14. Appliqué leaves 28* and 29*.
15. Appliqué kumquats 30 and 31.
16. Baste turned leaf 32 in place with a single unknotted thread. Appliqué leaf 33, then appliqué leaf section 34.
17. Use colored artists' pencils to add shading in the leaves and fruit. Stipple as desired.

Extend this piece at least ¼" past the edge of the finished block.

This block includes cut slices and sections of lemons. Remember to use ripe and unripened fruits for more color. Pen-and-ink stippling or pencil shading adds definition to the appliqué shapes.

Use the pattern on page 88. Prepare the master pattern following the instructions on page 14. For preconstruction, refer to pages 24–26. For the skinny stems, use the cut-to-shape technique on pages 22–23. Refer to page 21 for the turned leaves.

1. Prepare the background block as described on page 14.
2. Appliqué leaf 1*.
3. Appliqué turned leaf 2*/3.
4. Appliqué turned leaf section 4. Appliqué leaf 5* and leaf 6*.
5. Appliqué stems 7* and 8. Cut along the bias to prevent puckering.
6. Appliqué buds 9 and 10.
7. Appliqué petals 11–15. Leave the tip of petal 11 unappliquéd as shown on the pattern.
8. Appliqué stem 16. Appliqué the tip of petal 11.
9. Appliqué petals 17, 18, 19*, 20, 21, and center 22.
10. Appliqué leaf 23 and stem 24.
11. Appliqué turned leaf 25/26.
12. Appliqué leaf 27*.
13. Appliqué whole lemons 28, 29*, and 30*.
14. Preconstruct lemon slice 31*–35* and 36–38. (See pages 25–26.) Appliqué to the block.
15. Preconstruct lemon wedge 39*–41*. Appliqué to the block.
16. Stipple or shade as desired.

Extend this piece at least ¼" past the edge of the finished block.

pattern 7 C U R R A N T S

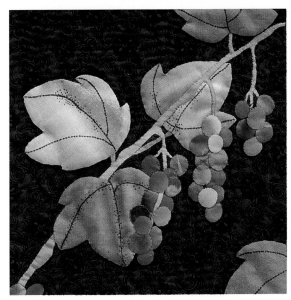

pattern 8 S T R A W B E R R I E S

Color, color, and more color! Change colors and values within the currants for the best results. Keep the color going as you choose fabrics for the leaves. Use blue-greens, yellow-greens, and true greens in different values.

Use the pattern on page 84. Prepare the master pattern following the instructions on page 14. For the currants, use the circle technique or the needle-turn berry technique on pages 23–24. Refer to pages 26–27 for instructions on pen-and-ink stippling and pencil shading.

1. Prepare the background block as described on page 14.
2. Appliqué stem 1.
3. Appliqué leaf 2.
4. Appliqué stems 3* and 4. Leave stem 3 unappliquéd where indicated on the pattern.
5. Appliqué leaves 5–7*. Appliqué the open portion of stem 3.
6. Appliqué currants 8* and 9*.
7. Appliqué currants 10–13. On berry clusters of any type, it is safest to appliqué the entire shape, even edges that will be covered by another berry. Leaving raw edges cuts down on appliqué time, but it can cause placement problems.
8. Appliqué stem 14.
9. Appliqué currants 15–22.
10. Appliqué currants 23–32.
11. Appliqué currants 33–38.
12. Appliqué leaf 39*.
13. Ink, embroider, or pencil shade the vein lines of all the leaves. Extend the veins on leaf 39 into the seam allowance.
14. Stipple and/or pencil shade as desired.

**Extend this piece at least ¼" past the edge of the finished block.*

Use the pattern on page 96. Prepare the master pattern following the instructions on page 14. For the stems, use the cut-to-shape technique on pages 22–23. Refer to page 21 for the turned leaves. Try the liquid-glue technique on page 13 for the leaves and strawberry tops. For preconstruction techniques, refer to pages 24–26.

1. Prepare the background block as described on page 14.
2. Preconstruct strawberry 1* and strawberry top 2*. Appliqué to the block.
3. Appliqué stem 3 and 4*. Appliqué leaves 5*, 6*, and 7. Appliqué berry 8* and leaf 9*.
4. Appliqué strawberry 10* and strawberry top 11–13.
5. Appliqué strawberry 14 and strawberry top 15.
6. Appliqué strawberry 16 and strawberry top 17–19.
7. Appliqué strawberry top 20–23 and strawberry 24*.
8. Appliqué leaf 25.
9. Appliqué stems 26–29. Breaking the stem into 3 pieces prevents the stem from showing under the blossom or berries.
10. Appliqué turned leaf section 30, leaf 31*, and turned leaf section 32. Appliqué stem 33 and turned leaf section 34.
11. Appliqué strawberry top 35 and 36, strawberry 37, and strawberry top 38.
12. Appliqué turned leaf section 39.
13. Appliqué strawberry blossom 40–43 and calyx 44.
14. Appliqué bud 45 and calyx 46.
15. Appliqué petals 47–51 and center 52.
16. Appliqué petals 53, 54*, and 55*, center 56, and petals 57 and 58.
17. Stipple and/or pencil shade as desired.

**Extend this piece at least ¼" past the edge of the finished block.*

pattern 1 B E E T S

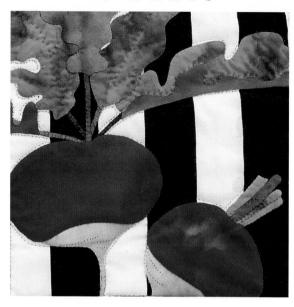

The gorgeous colors of the lowly beet are irresistible. Remember to show the brilliant red on the backs of the leaves.

Use the pattern on page 76. Prepare the master pattern following the instructions on page 14. For the skinny stems, use the cut-to-shape technique on pages 22–23. Refer to page 21 for the turned leaves. Refer to pages 26–27 for instructions on pen-and-ink stippling.

1. Prepare the background block as described on page 14.
2. Appliqué stems 1–5.
3. Appliqué turned leaf 6/7*.
4. Appliqué leaf 8*.
5. Appliqué turned leaf 9*/10*.
6. Appliqué leaves 11* and 12*.
7. Appliqué root 13* and beet 14*.
8. Appliqué beet stems 15–18.
9. Appliqué root 19* and beet 20*.
10. Stipple and/or pencil shade as desired.

**Extend this piece at least ¹⁄₄" past the edge of the finished block.*

pattern 2 L I M A B E A N S

Confess—no one liked lima beans as a child. They are, however, glorious to appliqué. Use this block as a color study in greens. Add withered or dying leaves for extra color, and try shading with colored pencils for special effects.

Use the pattern on page 89. Prepare the master pattern following the instructions on page 14. For the skinny stems, use the cut-to-shape technique on pages 22–23. Refer to pages 26–27 for instructions on pen-and-ink stippling and pencil shading.

1. Prepare the background block as described on page 14.
2. Appliqué stems 1* and 2*.
3. Appliqué bean 3*.
4. Appliqué stems 4–8.
5. Appliqué beans 9* and 10.
6. Appliqué leaf 11*.
7. Appliqué stem 12*.
8. Appliqué leaves 13, 14, 15*, and 16.
9. Appliqué stems 17* and 18*.
10. Appliqué beans 19*, 20*, 21*, and 22.
11. Appliqué leaves 23*, 24*, and 25*.
12. Stipple and/or pencil shade as desired.

**Extend this piece at least ¹⁄₄" past the edge of the finished block.*

pattern 3 CUCUMBER

Crisp, cool, and beautiful, cucumbers are a summer favorite in our house. Use a variety of greens for the best results.

Use the pattern on page 83. Prepare the master pattern following the instructions on page 14. For preconstruction techniques, refer to pages 24–26. Use the instructions on pages 26–27 for stippling the vein lines on the leaves.

1. Prepare the background block as described on pages 00–00.
2. Appliqué leaves 1, 2*, 3*, and 4. For leaves this large, it is easiest to stipple the vein lines before appliquéing the leaves.
3. Preconstruct cucumber slice 5*/6*. Appliqué to the block.
4. Appliqué cucumber sections 7*, 8*, 9*, and 10*. The cucumber in the photograph is a single piece of hand-painted fabric.
5. Preconstruct blossom 11–16 following the instructions for reverse appliqué on pages 21–22.
6. Ink, embroider, or pencil-shade details as desired.

Extend this piece at least ¼" past the edge of the finished block.

pattern 4 TOMATOES

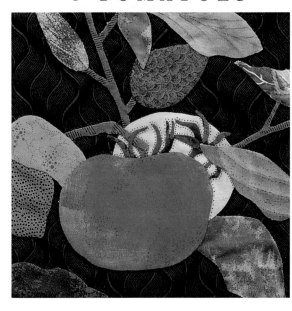

OK, OK, I know tomatoes can be classified as fruit. I included them in the vegetable section for color, but if you want to use them with the fruit blocks, please do so. Don't forget green tomatoes when you make your fabric choices.

Use the pattern on page 98. Prepare the master pattern following the instructions on page 14. For the skinny stems, use the cut-to-shape technique on pages 22–23. Refer to pages 26–27 for instructions on pen-and-ink stippling and pencil shading.

1. Prepare the background block as described on page 14.
2. Appliqué stem 1*.
3. Appliqué leaves 2, 3*, 4*, 5*, and 6*.
4. Appliqué tomato 7.
5. Appliqué stem 8* and leaf 9*.
6. Appliqué tomato top 10–15.
7. Appliqué leaf 16*.
8. Appliqué stems 17 and 18, then tomato top 19–23.
9. Appliqué leaves 24* and 25*.
10. Appliqué tomato 26.
11. Appliqué leaf 27*.

Extend this piece at least ¼" past the edge of the finished block.

pattern 5 BELL PEPPERS

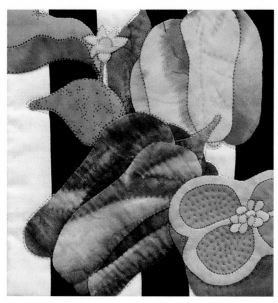

pattern 6 SERRANO CHILIES

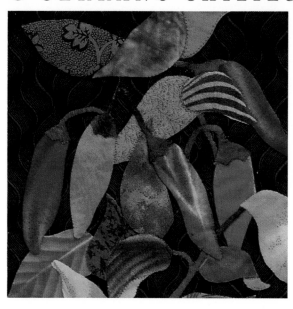

Investigate all varieties of peppers to add color to this block. Yellow, red, and purple peppers make a spectacular block.

Use the pattern on page 77. Prepare the master pattern following the instructions on page 14. Refer to page 21 for the turned leaf. Refer to pages 24–26 for preconstruction techniques. Use the cut-to-shape technique on pages 22–23 for the stem. Refer to page 24 for needle-turned organic shapes. Refer to pages 26–27 for instructions on pen-and-ink stippling and pencil shading.

1. Prepare the background block as described on page 14.
2. Appliqué leaf 1*.
3. Preconstruct turned leaf 2*/3*. Appliqué to the block.
4. Appliqué stem 4, blossom 5 and 6, blossom center 7, and turned petal 8.
5. Appliqué leaf 9.
6. Appliqué pepper sections 10–12, 13*, and 14*.
7. Appliqué pepper sections 15 and 16, then stem 17.
8. Preconstruct pepper section 19 to section 18. Appliqué to the block.
9. Appliqué pepper section 20.
10. Preconstruct pepper section 22 to section 21. Appliqué to the block.
11. Appliqué pepper section 23.
12. Baste pepper section 24* in place with a single unknotted thread. Since other shapes cover this piece, there is no need to appliqué it.
13. Appliqué pepper sections 25 and 26*.
14. Appliqué pepper cross section 27*.
15. Appliqué seeds 29–36.
16. Stipple and/or pencil shade as desired.

Extend this piece at least ¼" past the edge of the finished block.

Hot, hot, hot! The hotter the better. Bring that quality into your appliqué by including red, gold, and green in the chili peppers.

Use the pattern on page 95. Prepare the master pattern following the instructions on page 14. Refer to page 21 for the turned leaf. For the stems, use the cut-to-shape technique on pages 22–23. Refer to pages 26–27 for instructions on pen-and-ink stippling and pencil shading.

1. Prepare the background block as described on page 14.
2. Appliqué leaves 1* and 2.
3. Appliqué pepper 3* and cap/stem 4.
4. Appliqué stem 5.
5. Appliqué leaves 6 and 7.
6. Appliqué stem 8, pepper 9, and cap 10.
7. Appliqué leaf 11*.
8. Appliqué turned leaf 12/13.
9. Appliqué stem 14*.
10. Appliqué leaves 15*, 16*, 17*, and 18–20.
11. Appliqué stem 21, pepper 22, and cap 23.
12. Appliqué stem 24, pepper 25, and cap 26.
13. Appliqué pepper 27 and cap 28.
14. Appliqué leaf 29*.
15. Stipple and/or pencil shade as desired.

Extend this piece at least ¼" past the edge of the finished block.

pattern 7 SUGAR PEAS

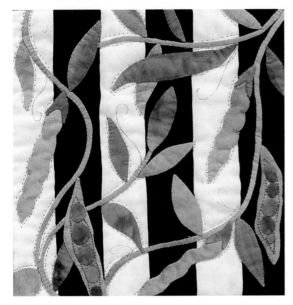

Like the lima beans, the sugar peas are a study in green. Be sure to include touches of color from reflected light for depth and dimension. For more color, consider making your sugar peas into purple hull peas.

Use the pattern on page 97. Prepare a master pattern following the instructions on page 14. For the skinny stems, use the cut-to-shape technique on pages 22–23. Refer to pages 21–22 for instructions on reverse appliqué. Follow the instructions on pages 24–26 for preconstruction. For pen-and-ink and pencil-shading techniques, refer to pages 26–27.

1. Prepare the background block as described on page 14.
2. Appliqué stems 1* and 2*.
3. Appliqué leaves 3*, 4*, 5*, 6*, and 7.
4. Appliqué pea pods 8–11.
5. Appliqué leaf 12, pea pod 13/14, and leaf 15.
6. Preconstruct pea pod 16–18 and peas 19–23. Reverse appliqué inner pod 17. Appliqué peas in numerical order. Appliqué the preconstructed unit to the block.
7. Appliqué leaf 24* and stems 25* and 26.
8. Appliqué leaves 27–31.
9. Preconstruct pea pod 32*/33* and peas 34–38 as described in step 6. Appliqué to the block
10. Appliqué pea pod 39/40.
11. Appliqué leaves 41 and 42.
12. Ink or embroider tendrils. Add stippling and pencil shading as desired.

**Extend this piece at least ¹/₄" past the edge of the finished block.*

pattern 8 OKRA

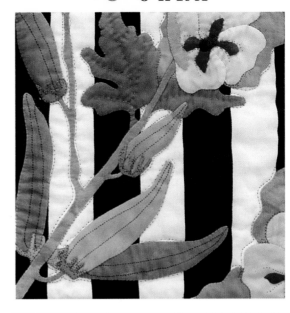

Fresh, hot gumbo or fried okra steaming on a platter elevate this lowly vegetable to a culinary delight. Okra flowers are magnificent. Grow okra for the beauty of the blossoms even if you do not eat it.

Use the pattern on page 91. Prepare a master pattern following the instructions on page 14. For the stems, use the cut-to-shape technique on pages 22–23. Try using the liquid-glue technique on page 13 for the okra tops. Refer to pages 26–27 for instructions on pen-and-ink stippling and pencil shading.

1. Prepare the background block as described on page 14.
2. Appliqué leaves 1*, 2, and 3*.
3. Appliqué stem 4.
4. Appliqué okra pod and top 5–8. The okra pods in the color photograph were cut from a single piece of hand-painted fabric, then stippled. Appliqué the pod in sections, or use a single piece of fabric.
5. Appliqué okra pods and tops 9–12.
6. Appliqué stem 13*.
7. Appliqué okra pods and tops 14*, 15*, 16*, and 17.
8. Appliqué okra pods and tops 18–21 and 22–25.
9. Appliqué leaves 26* and 27*, blossom 28*/29*, and flower center 30*.
10. Appliqué petals 31*, 32, 33*, and 34, flower center 35/36, and turned petal 37*.
11. Stipple and/or pencil shade as desired.

**Extend this piece at least ¹/₄" past the edge of the finished block.*

pattern 1 G A R L I C

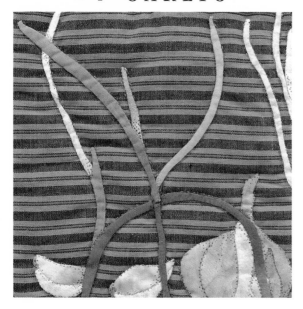

pattern 2 C O M F R E Y

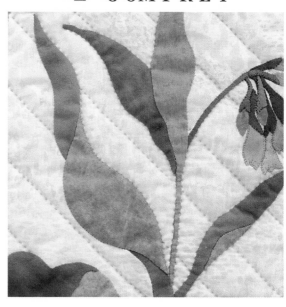

Garlic is widely used in all types of cooking. Its pungent flavor is perfect for meats, vegetables, and sauces. Health advocates also tout its medicinal qualities. I use it so much my family thinks garlic is a staple.

Use the pattern on page 85. Prepare a master pattern following the instructions on page 14. For the garlic tops or greens, refer to the cut-to-shape technique on pages 22–23. Read the section on turned leaves on page 21 for information on adding dimension to the turned tops. Refer to pages 26–27 for instructions on pen-and-ink stippling and pencil shading.

1. Prepare the background block as described on page 14.
2. Appliqué garlic tops 1*, 2*, and 3*.
3. Appliqué garlic bulb 4*, 5*, 6, 7*, 8*, and 9. Baste section 6 with a single unknotted thread. Since sections 7, 8, and 9 completely cover the edges of section 6, there is no need to appliqué it. Remove basting from the back of the block when finished.
4. Appliqué garlic cloves 10*–12 and 13–15. Consider value changes within each clove to add dimension.
5. Appliqué garlic tops 16*, 17, and 18* and 19, 20*, and 21.
6. Stipple and/or pencil shade as desired.

**Extend this piece at least ¼" past the edge of the finished block.*

Comfrey derives its name from the comfort it gave as a medicinal herb. Its healing properties are considerable. Use on sprains, swelling, and bruises or as a poultice on cuts and abscesses. Medieval physicians and herbalists always kept comfrey on hand. In cooking, young comfrey leaves make a pleasant alternative to spinach. Comfrey flowers range from creamy yellow to soft coral to purple.

Use the pattern on page 82. Prepare a master pattern following the instructions on page 14. Refer to page 21 for the turned leaves. Use the cut-to-shape technique on pages 22–23 for the stem. Refer to pages 24–26 for preconstruction techniques. Refer to pages 26–27 for instructions on stippling and pencil shading.

1. Prepare the background block as described on page 14.
2. Preconstruct turned leaf 1*/2. Appliqué to the block.
3. Appliqué turned leaf 3*/4*.
4. Appliqué blossom cluster 5–12, 13*, and 14.
5. Appliqué bud 15* and stem 16 and bud 17* and stem 18.
6. Appliqué leaves 19 and 20*. Make a value or color change for leaf 20 to indicate that the back of the leaf is showing.
7. Appliqué turned leaf 21*–23. Be sure to use a value or color change to show the turning of the leaf.
8. Stipple and/or pencil shade as desired.

**Extend this piece at least ¼" past the edge of the finished block.*

pattern 3 COLUMBINE

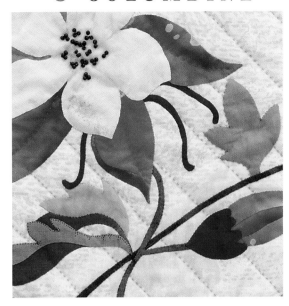

Columbine grows wild in many parts of the United States; it is also cultivated for its abundant nectar, which attracts bees and hummingbirds. Wild columbine grows in a variety of yellows and reds. Cultivated columbines are available in reds, whites, and blues. The blue-and-white columbine is the state flower of Colorado.

Use the pattern on page 81. Prepare a master pattern following the instructions on page 14. Refer to page 21 for turned leaves and petals. For the stems, use the cut-to-shape technique on pages 22–23. For preconstruction techniques, refer to pages 24–26. Refer to pages 26–27 for instructions on pen-and-ink stippling and pencil shading.

1. Prepare the background block as described on page 14.
2. Preconstruct leaves 1/2 and 3*/4*. Appliqué to the block.
3. Appliqué leaf 5 and stems 6* and 7*.
4. Appliqué bud 8, 9*, and 10* and calyx 11–14. The calyx of the columbine is always a bright, vivid color or white. For white blossoms, the calyx is blue or purple. For yellow blossoms, it is red, coral, or yellow. Look through seed catalogs for varieties.
5. Appliqué calyx tendrils 15–17.
6. Appliqué calyx petals 18–20, 21*/22*, 23*, 24*, and 25/26. The calyx petals in the color photograph were each cut from a single piece of hand-dyed fabric. Appliqué in sections or use a single piece of fabric. Baste calyx petals 23 and 24 with a single unknotted thread. Blossom 27 completely covers their edges, so there is no need to appliqué these petals. Remove the basting from the back of the block after appliquéing blossom 27.
7. Appliqué blossom 27*. Use beads, embroidery, or pen and ink for the blossom centers.
8. Stipple and/or pencil shade as desired.

**Extend this piece at least ¼" past the edge of the finished block.*

pattern 4 POPPIES

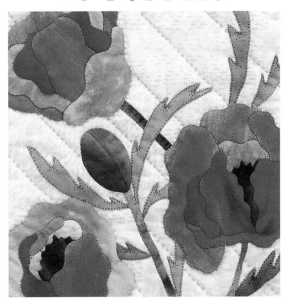

The poppy is one of my favorite flowers. Its brilliant colors range from white, pink, and rose to yellow, orange, and scarlet. Opium poppies provide the medical industry with a variety of narcotic drugs. The non-narcotic seeds make wonderful seasonings in bread, salad dressings, and oil.

Use the pattern on page 94. Prepare a master pattern following the instructions on page 14. For the stems, refer to the cut-to-shape technique on pages 22–23. Try the liquid-glue technique on page 13 for inner points on the leaves and flower centers. Refer to pages 26–27 for instructions on pen-and-ink stippling and pencil shading.

1. Prepare the background block as described on page 14.
2. Appliqué leaves 1* and 2*.
3. Appliqué stem 3 and leaves 4–8.
4. Appliqué stem 9*.
5. Appliqué leaf 10* and stem 11*.
6. Appliqué bulb 12/13. Use a slight value change to create dimension.
7. Appliqué blossom 14*–17*, 18–20, 21*, and 22.
8. Appliqué petals 23 and 24, center 25, and petals 26*, 27, 28*, 29, 30, and 31*.
9. Appliqué petals 32* and 33, center 34, and petals 35, 36*, and 37*.
10. Stipple and/or pencil shade as desired.

**Extend this piece at least ¼" past the edge of the finished block.*

pattern 5 HONEYSUCKLE

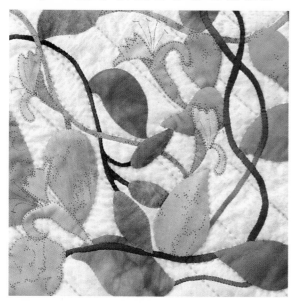

pattern 6 BASIL

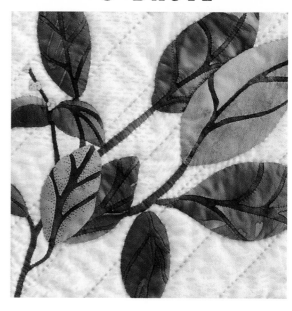

The aroma of honeysuckle blossoms is unforgettable. I remember plucking the stamen to lick the "honey" as a child. These flowers still provide flavor for home-remedy sore-throat syrups. Widely used in perfumes and potpourri, the strongly scented flowers are creamy yellow and orange, often with a slight purple tint on the outside.

Use the pattern on page 86. Prepare a master pattern following the instructions on page 14. For the inner points on the honeysuckle blossoms, use the liquid-glue technique described on page 13. Refer to pages 26–27 for instructions on pen-and-ink stippling and pencil shading.

1. Prepare the background block as described on page 14.
2. Appliqué stem 1 and leaf 2*.
3. Appliqué stems 3* and 4, leaf 5*, and stem 6*.
4. Appliqué leaves 7*, 8, and 9*.
5. Appliqué stem 10*.
6. Appliqué leaf 11 and blossom 12–14.
7. Appliqué stems 15* and 16*.
8. Appliqué leaves 17–19.
9. Appliqué leaf 20 and stem 21*.
10. Appliqué blossom 22–24.
11. Appliqué leaves 25 and 26* and petal 27.
12. Appliqué stem 28, leaving a section open as indicated on the pattern.
13. Appliqué leaf 29* and blossom 30. Appliqué the open section on stem 28.
14. Appliqué leaves 31, 32*, and 33*.
15. Appliqué blossom 34–36.
16. Stipple and/or pencil shade as desired.

*Extend this piece at least ¼" past the edge of the finished block.

Basil is predominately used as a culinary herb. The hearty, distinctive flavor is perfect with tomatoes and mushrooms. Purple basil, shown in the photograph, is also known as "Dark Opal." The main ingredient in pesto, basil also repels flies.

Use the pattern on page 75. Prepare a master pattern following the instructions on page 14. For reverse appliqué, refer to page 21. Use the cut-to-shape technique on pages 22–23 for the skinny stems. Preconstruct the vein lines in the leaves following the directions on pages 24–26. For the turned leaf, refer to page 21. Refer to pages 26–27 for instructions on pen-and-ink stippling and pencil shading.

1. Prepare the background block as described on page 14.
2. Appliqué stems 1*–7.
3. Preconstruct basil leaves 8*/9*, 10/11, and 12/13. Appliqué to the block.
4. Appliqué turned leaf 14/15*.
5. Preconstruct basil leaves 16/17, 18*/19*, 20*/21*, 22*/23*, 24*/25*, and 26*/27*. Appliqué to the block.
6. Add flowers and small leaves on stem 3, using beads, embroidery, or paint.
7. Stipple and/or pencil shade as desired.

*Extend this piece at least ¼" past the edge of the finished block.

pattern 7 B O R A G E

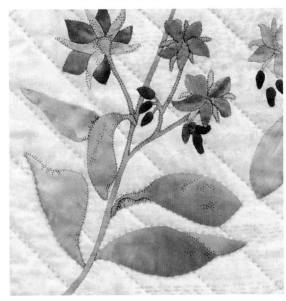

pattern 8 B L E E D I N G H E A R T S

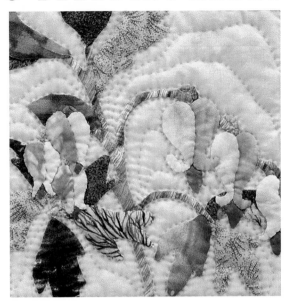

Brilliant blue star-shaped flowers are the trademark of the borage plant. Its shape and vivid color rarely appear in other plants. Borage, once thought to give courage, has a variety of culinary uses. The juicy, cucumber-flavored leaves are delightful in fruit cups, punch, and salads. The candied flowers decorate cakes and confections. Borage leaves also have medicinal uses.

Use the pattern on page 79. Prepare a master pattern following the instructions on page 14. For the stem, use the cut-to-shape technique on pages 22–23. Refer to page 21 for the turned leaves. For the star-shaped centers, use the liquid-glue technique described on page 13. Refer to pages 26–27 for instructions on pen-and-ink stippling and pencil shading.

1. Prepare the background block as described on page 14.
2. Appliqué blossom 1* and calyx 2*.
3. Appliqué leaves 3 and 4, turned leaves 5/6 and 7/8, and leaf 9*.
4. Appliqué stem 10* and leaf 11.
5. Appliqué calyx 12 in a single piece. The petals will fall over the center of the calyx; when you trace piece 12, draw soft concave curves where the calyx is hidden by petals.
6. Appliqué petals 13–17 and center 18.
7. Appliqué calyx 19 as described in step 5.
8. Appliqué petals 20–24 and center 25.
9. Appliqué or embellish seeds 26–31. The seeds in the photograph were appliquéd.
10. Appliqué calyx 32* as described in step 5.
11. Appliqué petals 33*, 34, 35, 36*, and 37 and center 38.
12. Appliqué or embellish seeds 39–42.
13. Stipple and/or pencil shade as desired.

**Extend this piece at least ¼" past the edge of the finished block.*

Once grown for medicinal purposes, this delicate plant is a garden favorite. The bleeding heart's name comes from the shape of the blossom. Bright red or fuchsia blossoms are most traditional, but bleeding hearts grow in a wide variety of colors.

Use the pattern on page 78. Prepare a master pattern following the instructions on page 14. Try the liquid-glue technique on page 13 for the inner points on the leaves. For the turned leaf, refer to page 21. Use the cut-to-shape technique on pages 22–23 for the stems. Refer to pages 26–27 for instructions on pen-and-ink stippling and pencil shading.

1. Prepare the background block as described on page 14.
2. Appliqué turned leaf 1/3, leaf 3*, and stem 4*. Leave the top edge of the upper right-hand branch of stem 4 open as shown on the pattern.
3. Appliqué leaf 5 and stem 6*.
4. Appliqué leaf 7*.
5. Appliqué stems 8 and 9, leaving the upper edges open as show on the pattern.
6. Fold back the unappliquéd sections of stems 4, 8, and 9. Appliqué stems 10–12 at the section marked X. Close unappliquéd sections of stems 5, 8, and 9; appliqué in place. Finish appliquéing stems 10–12.
7. Appliqué blossoms 13–15, 16–18, and 19, 20*, and 21.
8. Appliqué leaves 22* and 23.
9. Appliqué stems 24 and 25, leaf 26*, and stem 27.
10. Appliqué leaves 28 and 29*.
11. Appliqué stem 30 and leaves 31* and 32.
12. Appliqué blossoms 33–35, 36–38, and 39–41.
13. Stipple and/or pencil shade as desired.

**Extend this piece at least ¼" past the edge of the finished block.*

VERTICAL MEDALLION

Block size: 5" x 15"

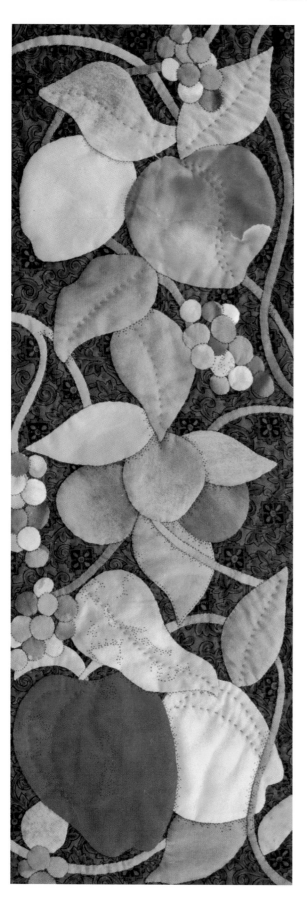

Use the pattern on pages 103–104. Prepare a master pattern as described below. For the currants, refer to the needle-turned circles technique on pages 23–24. Use the cut-to-shape technique on pages 22–23 for the stems. Refer to pages 26–27 for instructions on pen-and-ink stippling and pencil shading.

To prepare a master pattern for a medallion:

Cut a piece of freezer paper 2" larger than the finished size (7" x 17" for the vertical medallion and 14" x 20" for the horizontal medallion). For the vertical medallion, fold the paper in half crosswise. For the horizontal medallion, fold in half, then in half again. Draw horizontal guidelines parallel to the crosswise fold. For the horizontal medallion, draw another guideline along the vertical fold.

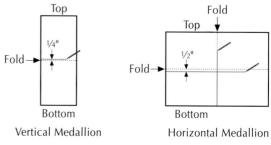

Vertical Medallion Horizontal Medallion

Place the freezer paper on the pattern in the book, matching the drawn lines to the dotted lines on the pattern. Trace as described in steps 3 and 4 on page 14.

1. Prepare the background block as described on page 14.
2. Appliqué stem 1*.
3. Appliqué leaf 2, currants 3, 4*, 5, and 6, and leaf 7.
4. Appliqué leaves 8 and 9 and stem 10.
5. Appliqué apples 11 and 12. Leave the upper edge of apple 11 open as indicated on the pattern.
6. Appliqué stem 13* and leaf 14*.
7. Appliqué plum 15, stem 16, leaf 17, and stem 18.
8. Appliqué leaf 19. Finish appliqué on apple 11.
9. Appliqué leaf 20 and currant cluster 21-31.
10. Appliqué plum 32, stem 33*, leaf 34, and plum 35.
11. Appliqué stem 36* and leaf 37. Appliqué currant cluster 38–47, extending currants 41, 44, and 46 into the seam allowance.
12. Appliqué leaf 48 and stems 49*–51*, 52, and 53.
13. Appliqué leaf 54, stem 55, and peach 56.
14. Appliqué stems 57*, 58, and 59* and leaves 60 and 61.
15. Appliqué peach 62 and currant cluster 63–77.
16. Appliqué currant cluster 78–87, extending currant 82 into the seam allowance.
17. Stipple and/or pencil shade as desired.

Extend this piece at least ¼" past the edge of the finished block.

HORIZONTAL MEDALLION

Block size: 12" x 18"

This beautiful arrangement includes fruit, vegetables, and herbs. What a wonderful way to show off your appliqué skills! Used alone or set into a project with other blocks, the horizontal medallion sings with all the colors and shapes of the garden. Don't be daunted by the seeming complexity of this medallion. Follow the numerical order, applying one shape at a time. Most of the shapes are from previous blocks, so you are familiar with how to appliqué them.

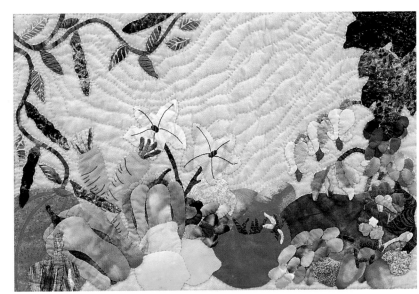

Use the pattern on pages 99–102. Prepare a master pattern and trace as described on page 14. For stems, use the cut-to-shape technique on pages 22–23. Refer to pages 24–26 for instructions on preconstruction. Follow the directions on page 21 for turned petals. Refer to pages 26–27 for instructions on pen-and-ink stippling and pencil shading.

1. Prepare the background block as described on page 14.
2. Appliqué leaves 1–3, stems 4* and 5*, and leaves 6 and 7.
3. Appliqué pea pod and top 8/9, leaf 10, and pea pod and top 11*/12.
4. Appliqué leaves 13–16.
5. Appliqué carrot section 17, carrot tops 18–21, and carrot 22 and 23.
6. Appliqué melon blossom stem 24. Preconstruct blossom 25/26; appliqué to the block.
7. Appliqué carrot section 27, carrot tops 28–31, and carrot 32.
8. Appliqué pea pod and top 33/34 and leaves 35 and 36.
9. Preconstruct melon rind stripes and top 38–45 onto melon 37. Appliqué to the block. Extend melon 37 and stripe 41 into the seam allowances.
10. Appliqué pea pod and top 46/47.
11. Appliqué melon blossom stem 48, kumquat 49, and leaf 50. Preconstruct blossom 51/52. Appliqué to the block.
12. Appliqué grapes 53–61. Appliqué bleeding heart stems 62–64. Leave top edges of stems unappliquéd as shown on pattern. Appliqué stems 65–67 at the section marked X. Appliqué the top edge of stems 62–64. Appliqué the remaining portion of stems 65–67.
13. Appliqué bleeding heart blossoms 68–76. Appliqué bleeding heart stems 77 and 78. Appliqué bleeding heart leaf 79 and stem 80.
14. Appliqué grape leaf 81*. Appliqué grape cluster 82–91. Appliqué grapes 92, 93*, and 94–97.
15. Appliqué eggplant 98. Leave open edge of eggplant as marked on pattern. Appliqué grapes 99–102, bleeding heart leaves 103 and 104, and eggplant top 105*.
16. Appliqué strawberry blossom stems 106–108. Appliqué petals 109–112, center 113, and turned petal 114. Appliqué petals 115–119 and center 120.
17. Appliqué strawberry leaf 121, strawberry tops 122–125, and berry 126. Appliqué strawberry tops 127 and 128, berry 129, and small leaf 130. Appliqué bud 131 and calyx 132.
18. Appliqué kumquat 133. Appliqué remaining portion of eggplant. Appliqué tomato 134 and tomato top 135–141. Appliqué tomato top 142–146 and tomato 147.
19. Appliqué grape stem 148 and grape cluster 149–163. Appliqué grape leaf 164. Appliqué strawberry top 165, berry 166, and leaves 167 and 168.
20. Appliqué lemon 169 and grapes 170–172.
21. Appliqué bell pepper sections 173 and 174 and stem 175. Preconstruct pepper section 176 to 177; appliqué to the block. Preconstruct pepper section 178 to 179; appliqué to the block. Preconstruct section 180 to section 181; appliqué to the block. Appliqué section 182.
22. Appliqué lemons 183 and 184*. Appliqué bell pepper sections 185 and 186 and stem 187. Preconstruct pepper section 188 to section 189; appliqué to the block. Appliqué pepper section 190. Preconstruct section 191 to section 192; appliqué to the block. Appliqué section 193.
23. Baste garlic section 194 in place with a single unknotted thread. Appliqué sections 195* and 196* in place. Turn to the back and remove the basting from section 194. Appliqué sections 197*–199*.
24. Appliqué pea pod and top 200/201.
25. Appliqué grape leaves 202* and 203*.
26. Stipple and/or pencil shade as desired.

Extend this piece at least ¼" past the edge of the finished block.

Each of these borders contains elements from the fruit and vegetable blocks. There is no law that says borders must be symmetrical. Try a border on the left side of the quilt only. Make a graceful arch with a border at the top only. Add a pieced border before or after the appliqué border. Try an asymmetrical border with appliqué on two sides. (Quilts with asymmetrical borders appear on pages 46, 49, and 56.)

This is your last chance to make a statement about the quilt. Take a risk with an unusual border treatment. Now is not the time to just cut some strips and sew them to the quilt top. Give the borders as much time and care as the quilt's interior.

General Directions

1. Prepare a piece of paper the finished length and width of your border.
2. Starting at the corners and working toward the middle, trace the pattern onto the paper, matching sections along the dashed lines. Continue adding sections until you reach the middle of your paper pattern.
3. Once you complete the tracing, adjust the pattern to fit your border. To shorten the border, shorten vines or replace large elements with small ones. To lengthen the original design, do the opposite.
4. Cut a piece of fabric for the border background, cutting it 2" wider and longer than the finished size to allow for shrinkage in sewing.
5. Appliqué the border first, then attach it to the quilt.

NOTE | On mitered or straight-cut corners, begin appliquéing a few inches from the corner. Attach the borders to the quilt top following the directions for mitered or straight-cut borders on pages 112–13, then complete the appliqué at the corner.

STRAWBERRIES & BLOSSOMS

Border width: 3"

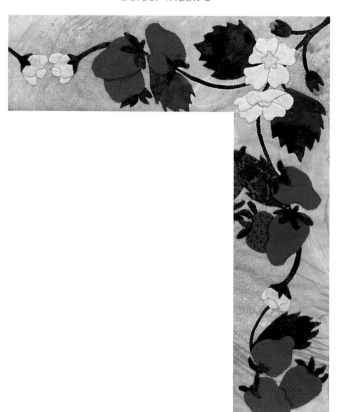

This graceful border adapts well to any quilt or garment. Use it as a sashing for a special project. See the pattern on pages 105–106.

1. Measure the quilt top and cut a 5"-wide strip the length of your quilt top plus 2". (For mitered borders, refer to the directions on pages 112–13.)
2. Make a master pattern by matching the letters at the dotted lines. Adjust as necessary.
3. Appliqué in numerical order. Use the cut-to-shape technique on pages 22–23 for the stems. The liquid-glue technique on page 13 works well on the serrated edges of the strawberry leaves.
4. Trim the border to the finished size, following the directions on page 112.
5. Repeat for any remaining borders, remembering to adjust the design at different points.
6. Sew the borders to the quilt, following the directions on page 112 for straight borders or pages 112–13 for mitered borders.
7. Appliqué the corner pieces in numerical order.

TOMATOES & CHILI PEPPERS

Border width: 5"

My husband cringed at the thought of tomatoes and chili peppers growing on the same vine. "Artistic license, dear," I replied. This border can be used in many ways, as shown in "Salsa Days" on page 48. It's fun and easy to appliqué and looks great. Show both ripe and unripe peppers and tomatoes for the most effective color work.

1. Measure the quilt top and cut a 7"-wide border strip the length of your quilt plus 2". (For mitered borders, refer to the directions on pages 112–13.)

2. Make a master pattern by matching the letters at the dotted lines. Adjust as necessary. If you are using the border as shown in "Garden Window" on page 52 or "Salsa Days" on page 48, leave the corner tomato in place. For straight-cut or mitered borders, remove this tomato. (See illustration.)

3. Starting with leaf 1, appliqué in numerical order. Use the cut-to-shape technique on pages 22–23 for the stems. Break the stems at the pepper caps as shown in the illustration for more color and ease in appliqué.

4. Trim the border to the finished size, following the directions on page 112.

5. Repeat for any remaining borders, remembering to adjust the design at different points.

6. Sew the borders to the quilt top, following the directions on page 112 for straight-cut borders or pages 112–13 for mitered borders.

7. Appliqué the corner pieces in numerical order.

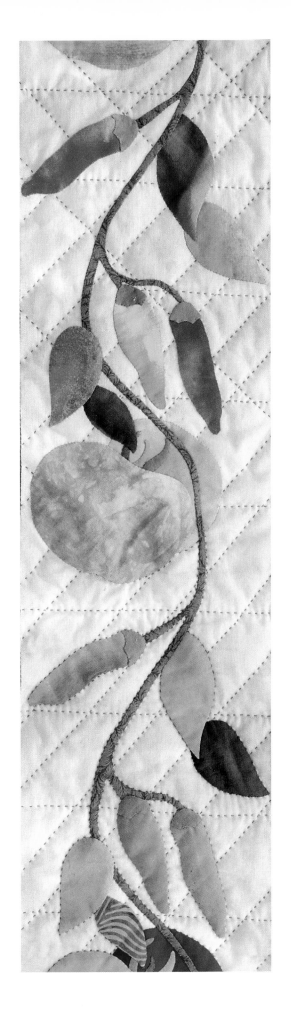

gallery

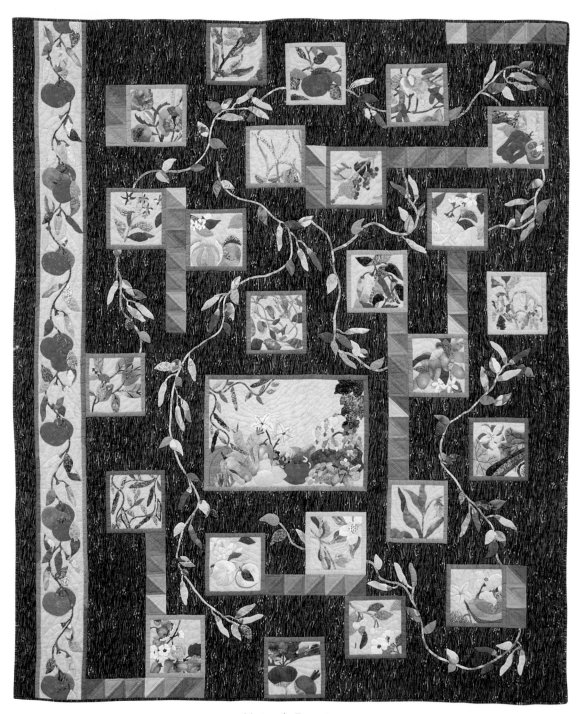

Nature's Bounty
by Joan Dawson, 1996
Bothell, Washington, 63" x 75"
*Joan created a show-stopper by combining blocks and a horizontal
medallion. The pepper border winding through the asymmetrical setting
is a wonderful touch that displays Joan's excellent eye for design.*

In the Light of the Moon
by Laura McGee, 1995
Arlington, Texas
16" x 23"
Quilted by Alice Wilhoite

Exquisite painting is the key to this lovely night garden. Laura's love of color is obvious.

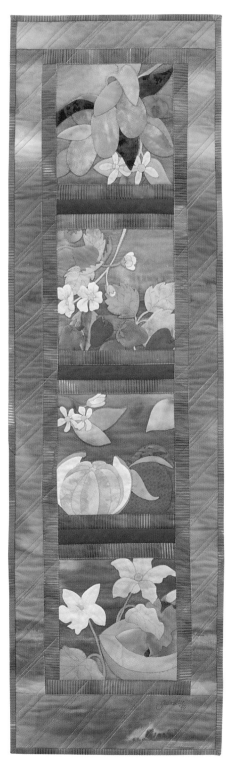

WOW! Veggies
by Janet Carija Brandt, 1995
Indianapolis, Indiana
16" x 16"
Janet Carija Brandt, author of "WOW! Wool-on-Wool Folk Art Quilts" brings her special touch to the vegetable blocks. The hand-dyed wool and button-hole stitches give this quilt warmth and whimsy.

Juicy Fruit
by Gabrielle Swain, 1995
Watauga, Texas,
11" x 36"
Quilted by Julia S. Sandlin

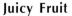

The "sky" background and simple setting fabrics make the blocks the focus of this gorgeous quilt. The title is in memory of my father, who always carried Juicy Fruit gum.

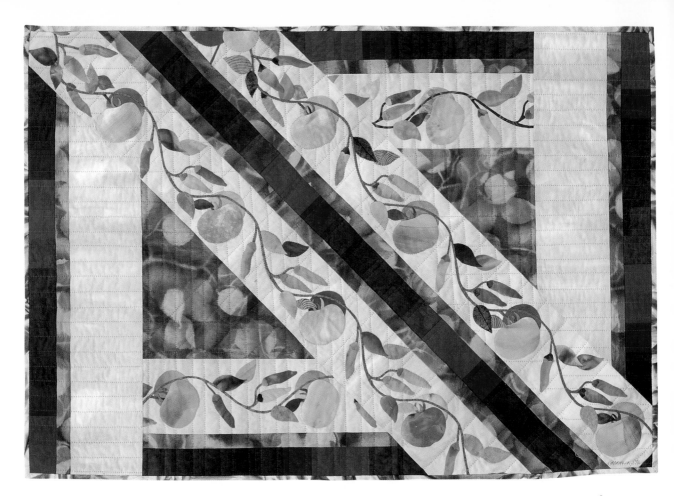

Salsa Days
by Gabrielle Swain, 1996
Watauga, Texas
30" x 44"

Using fabric as inspiration, I combined piecework with the Tomatoes and Chili Peppers border in this quilt.

Summertime
by Laura McGee, 1995
Arlington, Texas
18" x 24"
Quilted by Alice Wilhoite

The painting and quilting in this medallion are offset beautifully by the strong border treatment.

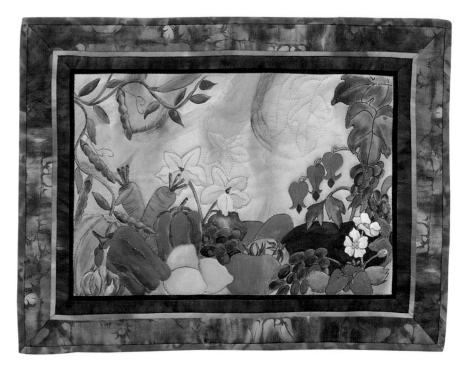

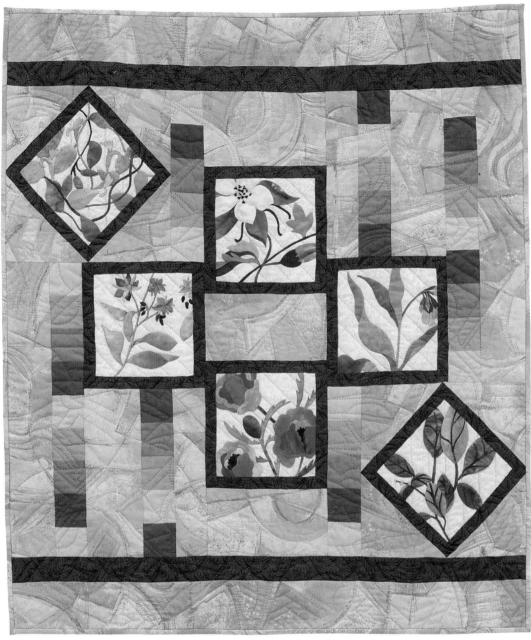

Potpourri
by Gabrielle Swain, 1996
Watauga, Texas
32" x 37"

I chose the symmetry of a formal herb garden for this
delightful quilt. The combination of on-point and straight-set
blocks gives this easy setting a more complex look.

Garden Nostalgia
by Noreen Kebart, 1995
Arlington, Texas
15¼" x 21⅛"

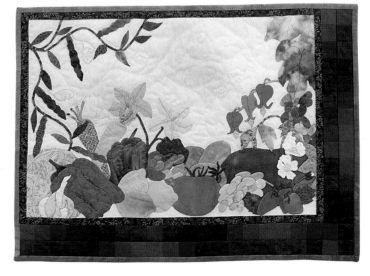

Simple yet exquisite, this medallion contains a beautiful
color balance within the appliqué. Noreen's quilt is named
in honor of the quilt shop where we tested the patterns.

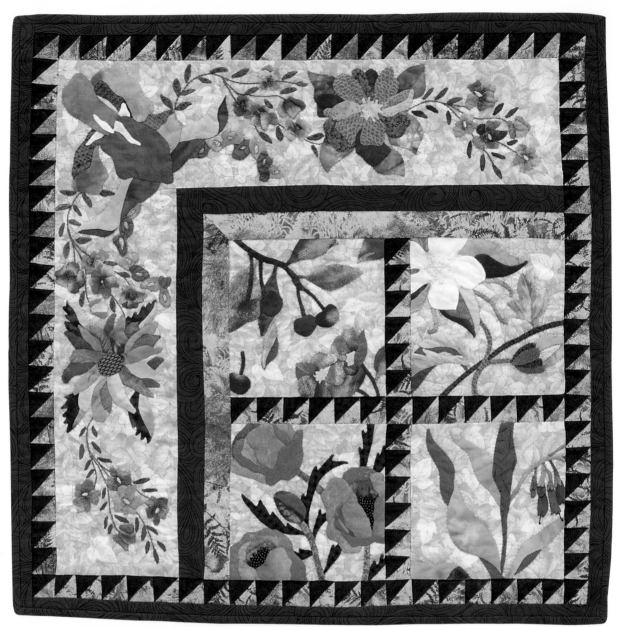

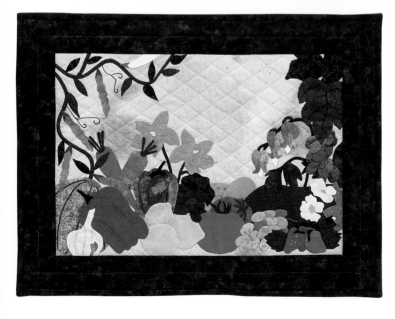

Summer's View
by Marilyn Mowry, 1995
Irving, Texas,
23" x 22½".

*My original border design was
executed by Marilyn in class two years ago.
Marilyn chose blocks with a strong floral motif
to complement the floral work of the border.
Her fabric selections add both realism and drama
to the completed quilt.*

The Fruits of My Labor
by Gabriele Fusee, 1996
Salem, New Hampshire
12" x 18"

*Gabriele is an online quilter I met this year. She used
some unusual fabrics and techniques in this medallion
to add dimension. By combining hand appliqué, machine
appliqué, and dimensional techniques, Gabriele
created a quilt that shows all her skills.*

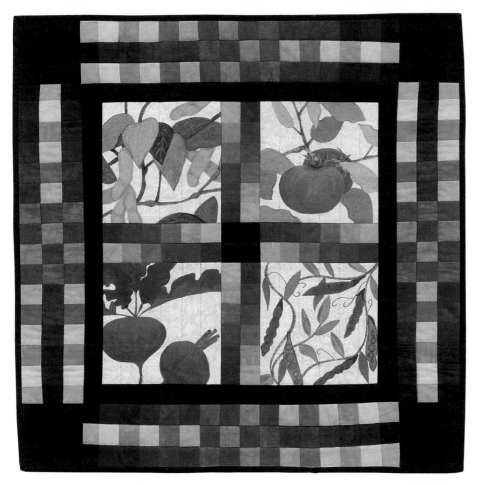

Painted Garden
by Helen Ruth Brandhurst, 1995
Watauga, Texas
22" x 22"

Painting the blocks made this a fast and fun project for Helen Ruth. Shading while the paint is wet gives the blocks the texture and dimension of appliqué.

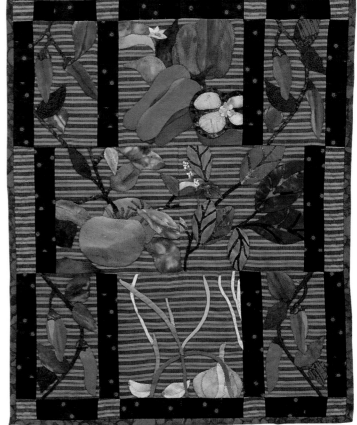

Rosani Wednesday
by Linda Cordell, 1995
Arlington, Texas
16" x 20"

The striped homespun background gives Linda's quilt a warm, homey feel. Linda works for a food-product corporation. The title refers to their tomato sauce.

Garden Window

by Joan Burckle, l995
Colleyville, Texas
20" x 20"

Joan's quilt is an example of beautiful appliqué and exquisite colorwork. The gradated background provides a delightful foundation for the blocks and border panels.

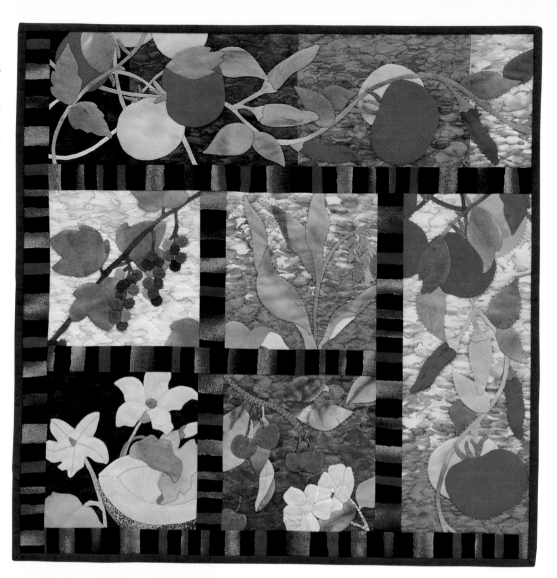

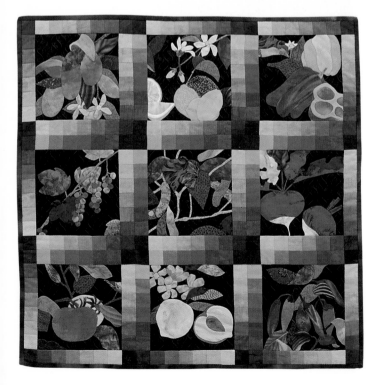

Garden at Midnight

by Noreen Kebart, 1995
Arlington, Texas
24¹/₄" x 24¹/₄"

A dark violet background combines beautifully with the multicolor gradated sashings in this exciting quilt.

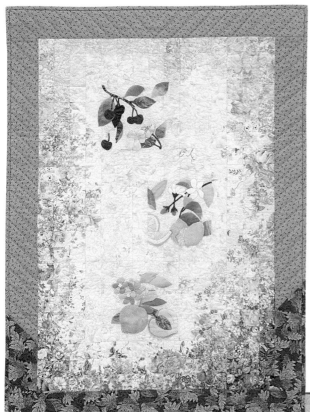

Strawberry Parfait
by Peggy Cord, 1995
Garland, Texas

The Strawberries and Blossoms border works
magic on Peggy's fun vest.

Pie in the Sky
by Donna Ingram Slusser, 1995
Pullman, Washington
28" x 38"

Donna Ingram Slusser of "Watercolor Quilts" fame found time to appliqué these blocks during her travels. The whimsical title refers to her favorite fruit pies. Beautiful watercolor piecing and hand-dyed fabric by Donna's husband, Lloyd, add much to this wonderful quilt.

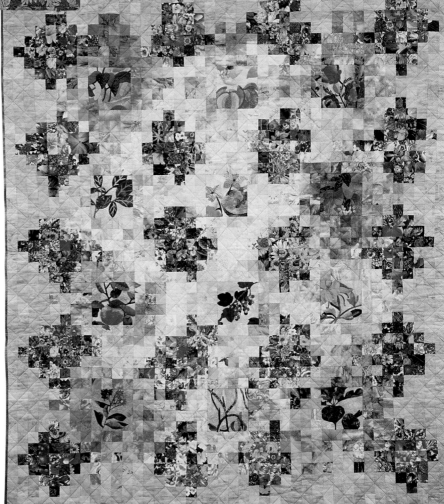

How Does Your Garden Grow?
by Ruth Cattles Cottrell, 1995
Irving, Texas
62" x 72"

The watercolor-quilt setting gives this lovely quilt a unique overall background.

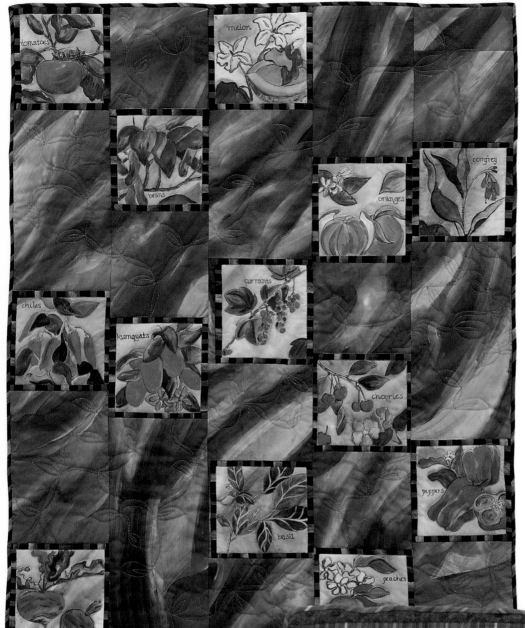

Rainy Days
by Laura McGee, 1995
Arlington, Texas
35" x 43"
Quilted by Linda V. Taylor

After searching in vain for setting fabrics, Laura decided to paint a background. The metallic quilting is reminiscent of glistening rain.

Delicious
by Gabrielle Swain, 1995
Watauga, Texas
18" x 24"

The blue-violet background provides an exciting foundation for the colorwork in these blocks. Hoping to convey the carnival atmosphere of an open-air market, I chose a striped fabric for the sashing and binding.

Summer's Bounty
by Helen Ruth Brandhurst, 1995
Watauga, Texas
18¾" x 40¾"

*"Masterpiece" is the only way to describe
this glorious quilt. Pieced sashings and
appliquéd borders highlight the realistic
color work in the blocks.*

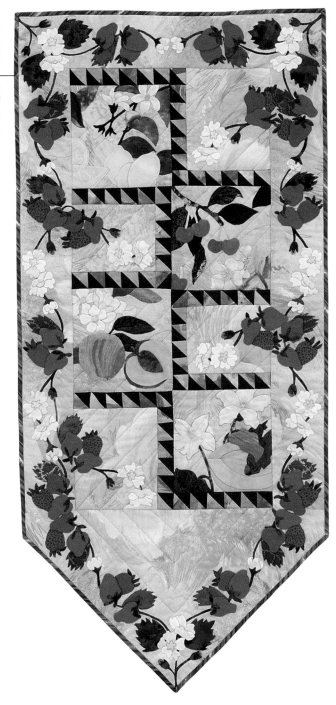

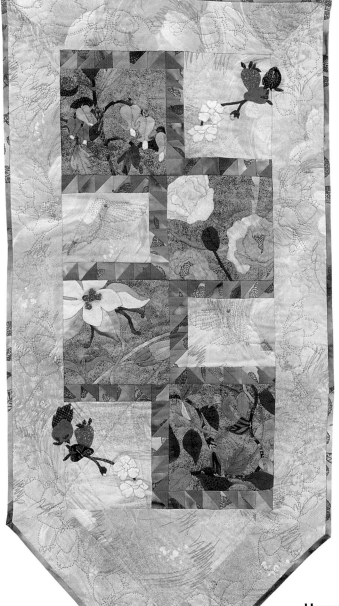

Hummingbirds in My Garden
by Gwen Offutt, 1995
Arlington, Texas
18¾" x 40¾"

*Gwen's quilting is the focus of the border and plain
blocks. The multicolored threads in the hummingbirds
offer realism while showcasing Gwen's skills.*

No More Monkeys
in Mary Kay's Strawberry Patch
by Gail Wells Curnutt, 1995
Arlington, Texas
8" x 8"

Gail's quilt was made for her sister, Mary Kay. An avid gardener, Mary Kay dreamed of monkeys eating the strawberries in her garden. The single-block medallion quilt made from plaids and stripes gives Mary Kay strawberries year 'round.

First Fruits
by Nikki Phillips, 1995
Morehead City, North Carolina
29" x 37"

Nikki and I met online this past year. The appliquéd trellis Nikki added to the Tomatoes and Chili Peppers border is an outstanding finish to this beautiful quilt.

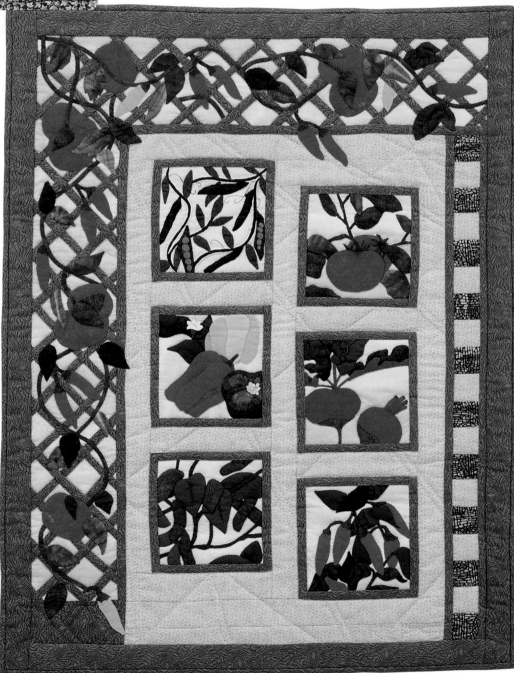

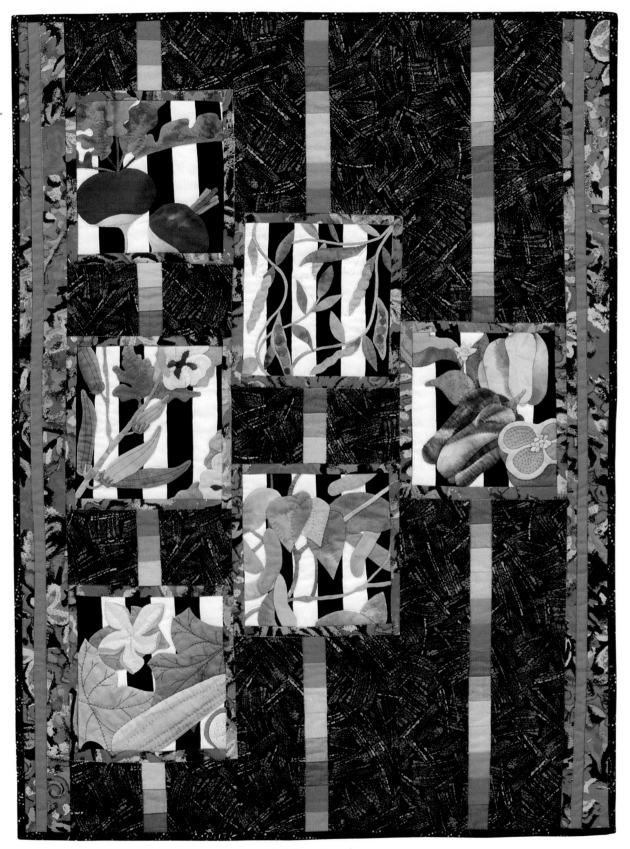

Eat Your Veggies
by Gabrielle Swain, 1995
Watauga, Texas, 24" x 32"
Quilted by Julia S. Sandlin

*Contemporary yet whimsical, this quilt was made to
tempt my sons to eat a more balanced diet.*

quilt SETS

Designing the quilt set is always exciting. The following projects range in style from contemporary to traditional. Each of the sets includes the blocks used in the quilts in the gallery. If you like a particular setting but do not want to use the blocks shown, use the blocks of your choice. It is amazing what a difference each block makes in a project.

Many of the quilt sets call for gradated fabrics. If you prefer to use print fabric, use the same amount listed for the gradated fabric.

SAUCE MIX

Finished size: 16" x 20"

Block sizes:
Feature blocks: 6" x 6"
Pepper panels: 3" x 6"

Color photo: page 51

This small quilt is a fast, easy project, perfect for any skill level. Within the blocks are the makings of a great pasta sauce. Make this project as a gift for your favorite cook—yourself.

Linda Cordell used a wonderful homespun stripe as the background in "Rosani Wednesday." I like the warm, homey feeling it gives the quilt. Linda works for a large food-product corporation, and her quilt honors their special Italian tomato sauce.

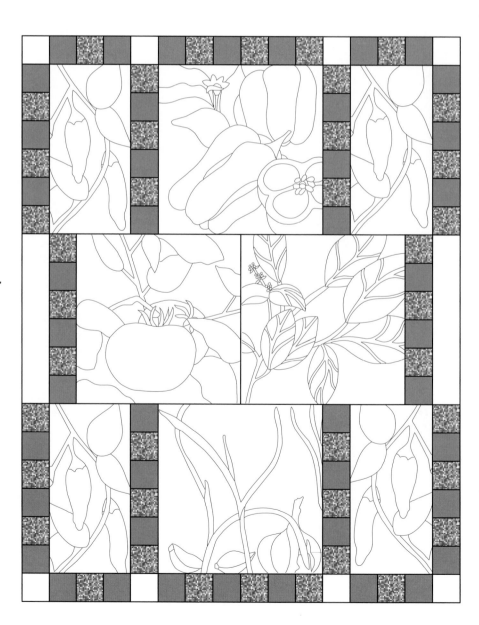

MATERIALS: *44"-wide fabric*

½ yd. background fabric for feature blocks
 and pepper panels
¼ yd. Color A for pieced sashings
¼ yd. Color B for pieced sashings
Assorted fabrics for appliqué
¼ yd. fabric for binding
⅔ yd. fabric for backing
20" x 24" piece of batting

CUTTING

The dimensions given for the feature block and pepper panel backgrounds include an additional 2" for shrinkage during appliqué.

From the background fabric, cut:

4 squares, each 8" x 8"
4 rectangles, each 5" x 8"
2 rectangles, each 1½" x 6½"
8 squares, each 1½" x 1½"

From Color A, cut:

3 strips, each 1½" x 42"

From Color B, cut:

3 strips, each 1½" x 42"

From the binding fabric, cut:

3 crosswise strips, each 2" wide

ASSEMBLY

1. Prepare and appliqué 4 feature blocks and 4 pepper panels. The pattern for the pepper panels is indicated by dashed lines on the Tomatoes and Chili Peppers border on page 00. Remember to reverse the pepper panel for 2 of the blocks. Trim the feature blocks to 6½" x 6½" and the pepper panels to 3½" x 6½".

2. Alternating fabrics, sew the Color A and Color B strips into a strip set as shown.

Make 1.

3. Crosscut the strip set at 1½" intervals to make 16 units.

1½"

Cut 16.

4. Sew 1 strip-pieced unit to each side of each pepper panel as shown.

Make 4.

5. Paying attention to the orientation of the pepper vines, sew a pepper panel made in step 4 to each side of the Bell Peppers block. Sew 1 of the remaining pepper panels to each side of the Garlic block.

6. Sew 1 strip-pieced unit to each 1½" x 6½" background rectangle as shown.

7. Sew 1 unit made in step 6 to the left side of the Tomatoes block, then sew the remaining unit to the right side of the Basil block.

8. Join the Tomatoes and Basil blocks as shown.

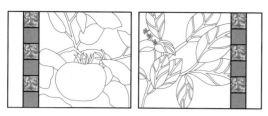

9. Sew one 1½" background square to each end of 2 strip-pieced units.

Make 2.

10. Using a seam ripper, gently remove 3 squares from each of the 4 remaining strip-pieced units to make 4 identical units.

Remove
3 squares.

Make 4.

11. Sew 1 unit made in step 10 to each end of each unit made in step 9. Add a 1½" background square to each end of the resulting unit.

Make 2.

12. Join the vegetable rows as shown.

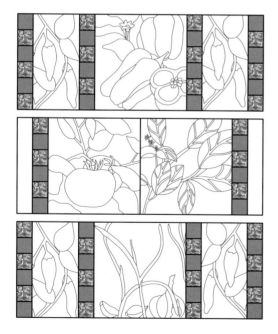

13. Add the units from step 11 to the top and bottom of the quilt top as shown, matching seams.

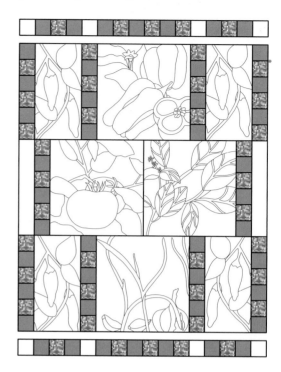

14. Layer the quilt top, batting, and backing. Baste.

15. Quilt as desired.

16. Trim the batting and backing even with quilt top. Bind the edges of the quilt.

PAINTED GARDEN

Finished size: 22" x 22"

Block size: 6" x 6"

Color photo: page 51

This is a painted project using the vegetable blocks, but you can try any of the blocks in appliqué or paint. Fruit or herb blocks would be smashing with multicolored gradated sashings and borders. The possibilities are endless with such a small, easy-to-accomplish project.

For "Painted Garden," Helen Ruth Brandhurst used a light print background for her blocks. It is obvious she is a talented painter. Her tomato block makes my mouth water. The shading in the blocks works best when the paint is wet and colors can be blended easily. (See pages 27–28.)

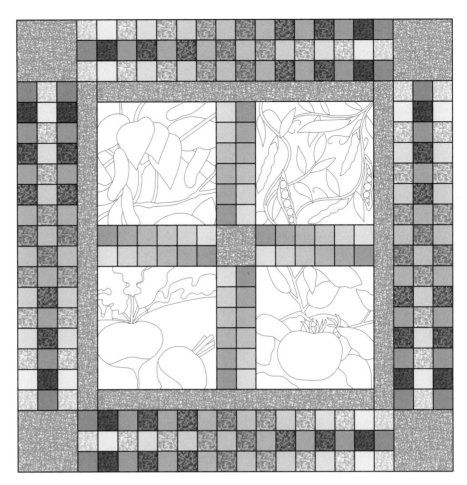

MATERIALS: *44"-wide fabric*

⅓ yd. background fabric for feature blocks

2 gradated fat quarter packs (18" x 22"), 8 steps each (16 fat quarters total), in coordinating colors, for checkerboard sashing and borders

¼ yd. fabric for sashing square, corner squares, and inner border

Assorted colors of fabric paint (or assorted fabrics for appliqué)

¼ yd. fabric for binding

¾ yd. fabric for backing

26" x 26" piece of batting

CUTTING

The dimensions given for the feature block backgrounds include an additional 2" for shrinkage during appliqué.

From the background fabric, cut:

4 squares, each 8" x 8"

From the gradated fat quarters, cut:

1 strip, 1½" x 15", from *each* of 6 steps in 1 pack for the sashing

1 strip, 1½" x 22", from *each* of 8 steps in both packs (16 total) for the outer border

From the sashing square fabric, cut:

1 square, 2½" x 2½", for the sashing square

4 squares, each 3½" x 3½", for the corner squares

2 strips, each 1½" x 14½", for the top and bottom inner borders

2 strips, each 1½" x 16½", for the side inner borders

From the binding fabric, cut:

3 crosswise strips, each 2" wide

ASSEMBLY

1. Paint or appliqué 4 feature blocks. (Refer to "Fabric Paint" on pages 27–28.) Trim the blocks to 6½" x 6½".
2. Join the six 1½" x 15" gradated strips into a strip set as shown.

3. Crosscut the strip set at 1½" intervals for 8 strip-pieced units.

Cut 8.

4. Sew the units into pairs as shown, flipping 1 unit in each pair so light is opposite dark.

Make 4.

5. Sew 1 sashing unit between 2 blocks for each row.

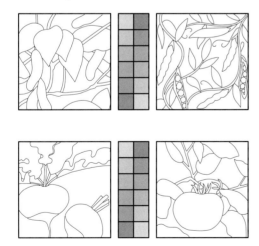

6. Sew the remaining sashing units to opposite sides of the 2½" sashing square as shown.

7. Sew the sashing strip made in step 6 to the rows.

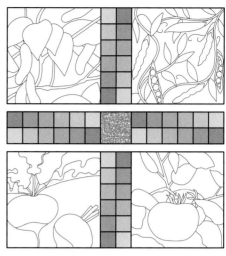

8. Sew 1½" x 14½" inner border strips to the top and bottom of the quilt top.

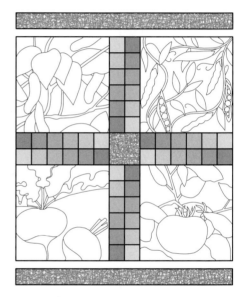

9. Sew 1½" x 16½" inner border strips to the side edges.

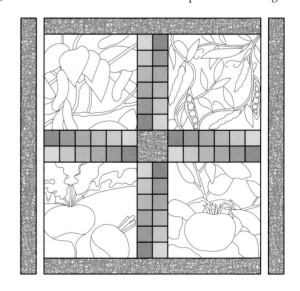

10. Sew the 16 gradated strips into a strip set as shown, starting with the lightest strips and alternating color sets as you go.

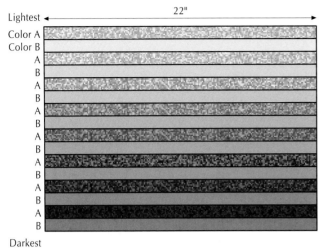

Lightest
Color A
Color B
A
B
A
B
A
B
A
B
A
B
A
B
A
B
Darkest

22"

11. Crosscut the strip set at 1½" intervals to make 12 strip-pieced units.

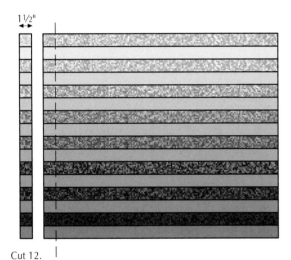

1½"

Cut 12.

12. Sew the units into 4 groups of 3, flipping the middle unit in each group so light is opposite dark.

Make 4.

13. Sew pieced borders to the sides of the quilt top as shown.

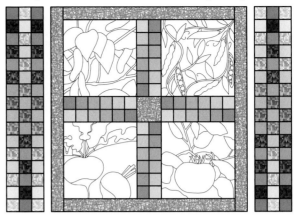

14. Sew a 3½" corner square to each end of the remaining pieced borders.

Make 2.

15. Sew units made in step 14 to the top and bottom of the quilt top, matching the seams of the corner squares and side borders.

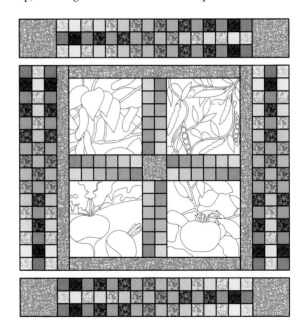

16. Layer the quilt top, batting, and backing. Baste.
17. Quilt as desired.
18. Trim the batting and backing even with quilt top. Bind the edges of the quilt.

GARDEN WINDOW

Finished size: 20" x 20"

Block sizes:
Feature Blocks: 6" x 6"
Tomatoes and Chili Peppers
Sections:
5" x 19" and 5" x 13"

Color photo: page 52

This lovely quilt combines blocks and borders in the body of the quilt. Using the Tomatoes and Chili Peppers border asymmetrically gives the project a contemporary feel. It also keeps the border from overwhelming the small number of feature blocks.

Joan Burckle chose a geometric fabric for her sashing. For a different look, try a pieced sashing of 1" squares. Pieced or printed, geometric patterns offset the curvilinear designs of the blocks nicely.

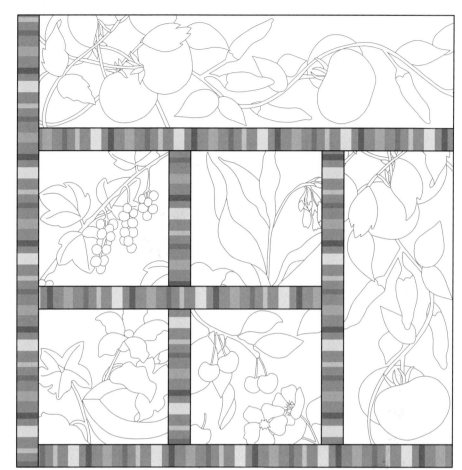

MATERIALS: *44"-wide fabric*

⅓ yd. background fabric for feature blocks (½ yd. if using 1 background fabric throughout)

¼ yd. background fabric for Tomatoes and Chili Peppers sections (omit if using 1 background fabric)

¼ yd. fabric for sashing and border

Assorted fabrics for appliqué

¼ yd. fabric for binding

⅔ yd. fabric for backing

24" x 24" piece of batting

CUTTING

The dimensions given for the blocks and the Tomatoes and Chili Peppers sections include an additional 2" for shrinkage during appliqué.

From the background for the feature blocks, cut:

4 squares, each 8" x 8"

From the background for the Tomatoes and Chili Peppers sections, cut:

1 piece, 7" x 21"
1 piece, 7" x 15"

From the sashing and border fabric, cut:

2 strips, each 1½" x 6½", for the sashing
2 strips, each 1½" x 13½", for the sashing
2 strips, each 1½" x 19½", for the sashing and bottom border
1 strip, 1½" x 20½", for the side border

From the binding fabric, cut:

3 crosswise strips, each 2" wide

ASSEMBLY

1. Prepare and appliqué 4 feature blocks. Trim to 6½" x 6½".

2. Using the pattern on pages 107–11, prepare and appliqué 2 Tomatoes and Chili Peppers sections. Choose any section of the border that pleases you. Allow the appliqué shapes to extend into the seam allowances as in the feature blocks. The sections in "Garden Window" on page 52 both started at the top left corner of the design.

3. Trim the 7" x 15" background piece to 5½" x 13½". Trim the 7" x 21" background piece to 5½" x 19½".

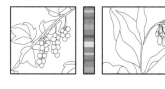

4. Sew a feature block to either side of a 1½" x 6½" sashing strip for each row as shown.

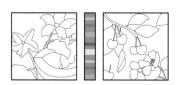

5. Sew the units from step 4 to either side of a 1½" x 13½" sashing strip as shown.

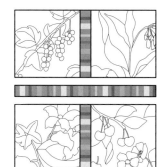

6. Sew the remaining 1½" x 13½" sashing strip to the left side of the 5½" x 13½" tomatoes and chili peppers section. Join this unit to the 4-block unit from step 5.

7. Sew the 1½" x 19½" sashing strip to the bottom of the 5½" x 19½" Tomatoes and Chili Peppers section. Join this unit to the unit from step 6 as shown.

8. Sew the 1½" x 19½" border strip to the bottom of the quilt top. Add the 1½" x 20½" border strip to the left side.

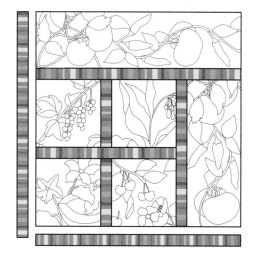

9. Layer the quilt top, batting, and backing. Baste.

10. Quilt as desired.

11. Trim the batting and backing even with quilt top. Bind the edges of the quilt.

SALSA DAYS

Finished size: 30" x 43"

Block sizes:
(dimensions include extra
for squaring up)

Horizontal Border Panels:
5" x 20" and 5" x 18"
Diagonal Border Panels:
5 " x 54"

Color photo: page 48

This is one of my favorite quilt sets. The construction techniques allow both the beginner and the experienced quiltmaker an opportunity to construct something other than a traditional set. Follow the instructions carefully for the best results. No templates are required for construction of this quilt.

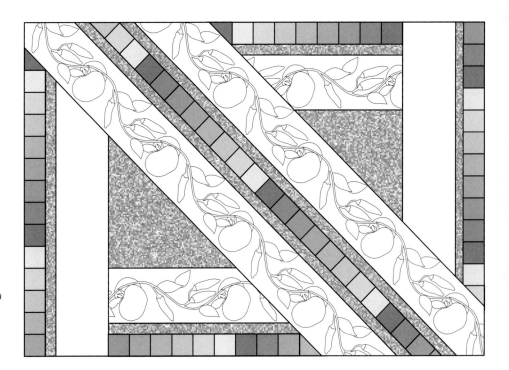

MATERIALS: *44"-wide fabric*

1⅝ yds. background fabric #1 for feature blocks and setting panels
½ yd. background fabric #2 for setting triangles*
½ yd. print for setting strips*
One 8-step fat quarter pack (18" x 22") of gradated fabrics for sashing
Assorted fabrics for appliqué
½ yd. fabric for binding
1⅓ yds. fabric for backing
34" x 47" piece of batting

** In the quilt on page 48, one fabric was used for both the background fabric and setting strips.*

CUTTING

The dimensions given for the appliqué background panels include an additional 2" for shrinkage during appliqué.

From the *lengthwise grain* of background fabric #1, cut:

2 panels, each 7" x 54"

From the remaining background fabric #1, cut:

1 panel, 7" x 20"
1 panel, 7" x 18"
1 panel, 5½" x 30½"
1 panel, 5½" x 28½"

From background fabric #2, cut:

1 square, 13" x 13"

From the print, cut:

1 strip, 1½" x 22½"
1 strip, 1½" x 30½"
1 strip, 1½" x 20½"
1 strip, 1½" x 28½"
4 strips, each 1½" x 42"

From *each* of the 8 gradated fat quarters, cut:

2 strips, each 2½" x 22", for a total of 16 strips

From the binding fabric, cut:

5 crosswise strips, each 2" wide

ASSEMBLY

1. Prepare and appliqué the four 7"-wide appliqué panels. Trim the panels to 5½" wide. Do not trim the length.

2. Sew the 2½" x 22" gradated strips into 2 strip sets as shown. Start with the lightest fabric and arrange in order of value.

Make 2.

3. Cut 10 units from the strip sets, each 2½" wide. Join the strip-pieced units light end to dark end to make one continuous strip, then separate squares with a seam ripper to create the following: 1 strip with 15 squares, 1 strip with 14 squares, 1 strip with 11 squares, 1 strip with 10 squares, and 1 strip with 27 squares.

Cut 10.

Join units.　　　Join.

10-square strip

11-square strip

14-square strip

15-square strip

27-square strip

4. Cut the 13" background square in half diagonally. Trim the short sides of 1 resulting triangle to 12½" each.

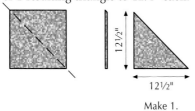

Make 1.

5. Sew the 5½" x 20" appliqué panel to the setting triangle as shown. Do not trim excess length from appliqué panel.

Do not trim.

6. Sew the 1½" x 22½" print strip to the 11-square gradated strip.

7. Sew the unit from step 6 to the appliqué unit as shown.

8. Using a ruler with a 45° angle, trim the appliqué and piecing to match the diagonal edge of the setting triangle. Be careful: all the edges are cut on the bias.

Trim at a 45° angle.

9. Sew the 1½" x 30½" print strip, the 15-square gradated strip, and the 5½" x 30½" background panel together as shown.

10. Join the unit from step 9 to the triangle unit from step 8 as shown. Using a ruler with a 45° angle, trim the strips to match the diagonal edge of the triangle unit.

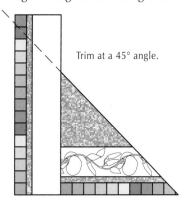

Trim at a 45° angle.

11. Trim the short sides of the remaining background triangle from step 4 to 10½" each.

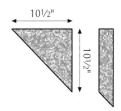

10½"

10½"

12. Sew the 5½" x 18" appliqué panel to the setting triangle as shown. Do not trim the excess length from the appliqué.

Do not trim.

13. Sew the 1½" x 20½" setting strip to the 10-square gradated strip.

14. Join the unit from step 13 to the appliqué unit from step 12 as shown. Using a ruler with a 45° angle, trim the appliqué and piecing to match the diagonal edge of the setting triangle. Be careful: all the edges are cut on the bias.

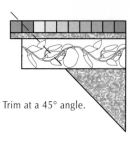

Trim at a 45° angle.

15. Sew the 1½" x 28½" print strip, the 14-square gradated strip, and the 5½" x 28½" strip together as shown.

16. Sew the resulting unit to the triangle unit made in step 14. Using a ruler with a 45° angle, trim the strips to match the diagonal edge of the triangle unit.

Trim at a 45° angle.

17. Sew the 1½" x 42" print strips end to end to make 2 strips, each 1½" x 83½" Trim these strips to 54½" each.

18. Sew 1 pieced strip to each side of the 27-square gradated strip.

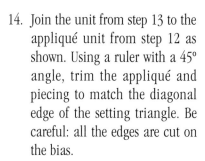

19. Sew a 5½" x 54" appliqué panel to each side of the gradated unit made in step 18, offsetting as shown to complete the diagonal panel.

about 5½"

about 3¾"

20. Sew the triangle unit from step 10 to the left side of the diagonal panel, matching the center of the appliqué panel to the center of the setting triangle. Sew the triangle unit from step 16 to the right side of the diagonal panel, again matching the center of the appliqué panel to the center of the setting triangle.

22. Layer the quilt top, batting, and backing. Baste.
23. Quilt as desired.
24. Trim the batting and backing even with quilt top. Bind the edges, using a ¼"-wide allowance.

Sew triangles to diagonal panel.

21. Square the edges of the quilt as shown. Stay-stitch the edges of the appliqué panel to prevent the bias edge from stretching.

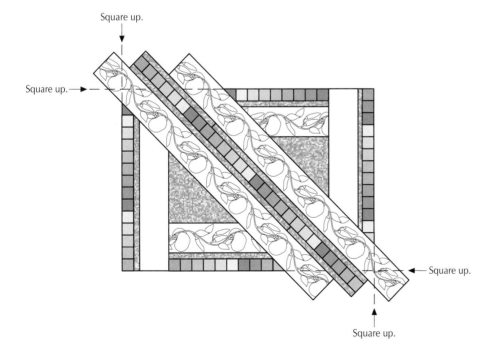

Square up.

Square up.

Square up.

Square up.

DELICIOUS

Finished size: 25" x 21"

Block sizes:
Feature Blocks: 6" x 6"
Vertical Medallion: 5" x 15"

Color photo: page 54

This quilt reminds me of all the colors in an open-air market. The striped fabric in the sashings and binding adds gaiety. Delay choosing your sashing and binding until you complete the blocks. It is worth the wait to audition several fabrics.

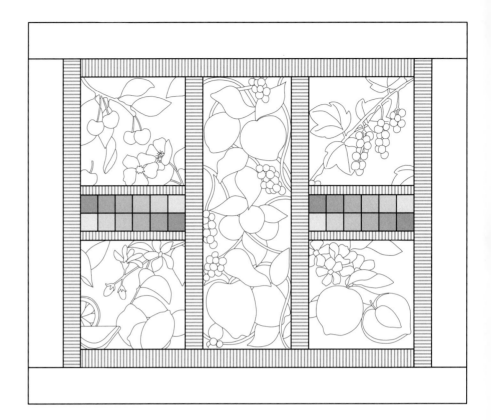

MATERIALS: *44"-wide fabric*

½ yd. background fabric for feature blocks and vertical medallion
⅛ yd. *each* of 6 solids for pieced sashings
¼ yd. stripe for sashings and inner border
¼ yd. fabric for outer border
Assorted fabrics for appliqué
¼ yd. fabric for binding
¾ yd. fabric for backing
29" x 25" piece of batting

CUTTING

The dimensions for the feature block and vertical medallion backgrounds include an additional 2" for shrinkage during appliqué.

From the background for the feature blocks, cut:

4 squares, each 8" x 8"
1 rectangle, 7" x 17"

From *each* of the 6 solids, cut:

1 strip, 1½" x 10"

From the stripe, cut:

2 strips, each 1½" x 15½", for sashing
4 strips, each 1" x 6½", for sashing
2 strips, each 1½" x 42", for inner border

From the outer border fabric, cut:

2 strips, each 2½" x 42"

From the binding fabric, cut:

3 crosswise strips, each 2" wide (Use bias binding for a scalloped border; see the Note on page 71.)

ASSEMBLY

1. Prepare and appliqué 4 feature blocks and 1 vertical medallion. Trim the blocks to 6½" x 6½". Trim the vertical medallion to 5½" x 15½".

2. Alternating colors, sew the 1½" x 10" solid strips into a strip set as shown.

3. Crosscut the strip set at 1½" intervals to make 4 strip-pieced units.

Cut 4.

4. Join the strip-pieced units as shown.

Make 2.

5. Sew a 1" x 6½" sashing strip to the top and bottom of each strip-pieced unit.

Make 2.

6. Sew the sashing units made in step 5 between feature blocks as shown.

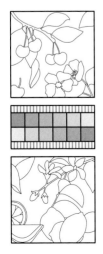

7. Sew one 1½" x 15½" sashing strip to each side of the medallion.

8. Join the vertical rows as shown.

9. Referring to "Straight-Cut Borders" on page 112, measure the quilt top and trim the 1½"-wide inner border strips to fit. Sew the border strips to the quilt.

10. Measure, trim, and add 2½"-wide outer border strips in the same manner.

11. Layer the quilt top, batting, and backing. Baste.

12. Quilt as desired.

13. Trim the batting and backing even with quilt top. Bind the edges.

NOTE │ The instructions given are for a straight-edged outer border. The border of the quilt on page 54 has a gentle, random scallop and rounded corners. If you want a scalloped border, cut the scallop after adding the borders to the quilt top. To cut the rounded corners and scallops, place a glass or jar lid at the corners and trace around the edge. Continue to move the "template" across the border at random intervals and trace the scallop. Cut along the drawn line. Bind with bias binding.

EAT
YOUR
VEGGIES

Finished size: 25" x 33"

Block size: 6" x 6"

Color photo: page 57

This quilt is born from total whimsy. My sons have never been fond of green things. One of them thinks eating five servings of vegetables a day means ordering hamburgers with lettuce and tomatoes. On the other hand, they all love black with bright colors. I doubt this quilt will tempt any of them to chow down on okra or lima beans, but they finally admitted it was cool.

MATERIALS: *44"-wide fabric*

½ yd. background fabric for feature blocks
¼ yd. fabric for framing strips
½ yd. background fabric for setting strips
1 hand-dyed fabric pack consisting of 6 fat quarters (3 red and 3 green in the quilt on page 57)
¼ yd. print for border
⅛ yd. solid for border
Assorted fabrics for appliqué
29" x 37" piece of batting
1⅛ yds. fabric for backing
⅓ yd. fabric for binding

CUTTING

The dimensions given for the feature block backgrounds include an additional 2" for shrinkage during appliqué.

From the background for the feature blocks, cut:

6 squares, each 8" x 8"

From the framing fabric, cut:

12 strips, each 1" x 6½"
12 strips, each 1" x 8½"

From the setting fabric, cut:

10 squares, each 3½" x 3½"
4 rectangles, each 3½" x 8½"
4 rectangles, each 3½" x 13½"

From *each* of the 6 fat quarters, cut:

1 strip, 1½" x 22"

From the border print, cut:

2 strips, each 1" x 42"
2 strips, each 1½" x 42"

From the border solid, cut:

2 strips, each 1" x 42"

From the binding fabric, cut:

4 crosswise strips, each 2" wide

ASSEMBLY

1. Prepare and appliqué 6 feature blocks. Trim to 6½" x 6½".
2. Sew 1" x 6½" framing strips to the top and bottom of the blocks, then sew 1" x 8½" framing strips to each side.

3. Sew the 1½" x 22" gradated strips into strip sets and cross-cut at 1½" intervals to make the following:

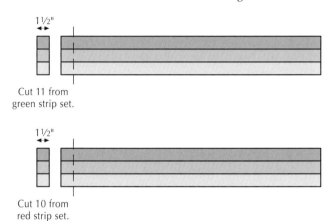

Cut 11 from green strip set.

Cut 10 from red strip set.

4. Join 3 units end to end as shown. Carefully remove a square with a seam riper to make an 8-square unit. Repeat to make a second 8-square unit.

Remove 1 square.

Red　Green　Red

Make two 8-square units.

5. Join 5 strip units end to end as shown. Carefully remove 2 squares to make a 13-square unit. Repeat to make a second 13-square unit.

Remove 2 squares.

Green　Red　Green　Red　Green

Make two 13-square units.

6. Sew one 3½" setting square to each side of each remaining 3-square unit as shown.

Make 5
(3 green, 2 red).

7. Sew a 3½" x 8½" setting rectangle to each side of each gradated 8-square unit.

Make 2.

8. Repeat step 7, using 3½" x 13½" setting rectangle and 13-square gradated units.

Make 2.

9. Sew one 3-square section to the top of each of 3 feature blocks. Sew the blocks together as shown. Sew a 3-square section to the bottom of this unit as shown.

10. Sew an 8-square section to the top of 1 feature block. Sew the remaining 3-square unit to the bottom of the same block.

11. Sew one 8-square section to the bottom of 1 feature block. Join this unit to the unit from step 10.

12. Sew 13-square gradated units to the top and bottom of the remaining feature block.

13. Join the units as shown.

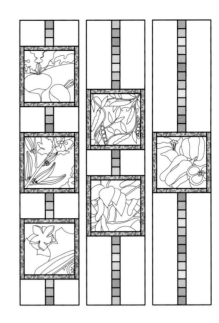

14. Sew a 1" x 42" print border strip, a 1" x 42" solid border strip, and a 1½" x 42" print border strip together as shown. Make 2 border units.

Make 2.

15. Referring to "Straight-Cut Borders" on page 112, measure and cut the border units. Sew a border unit to each side of the quilt top.

16. Layer the quilt top, batting, and backing. Baste.

17. Quilt as desired.

18. Trim the batting and backing even with quilt top. Bind the edges of the quilt top.

block PATTERNS

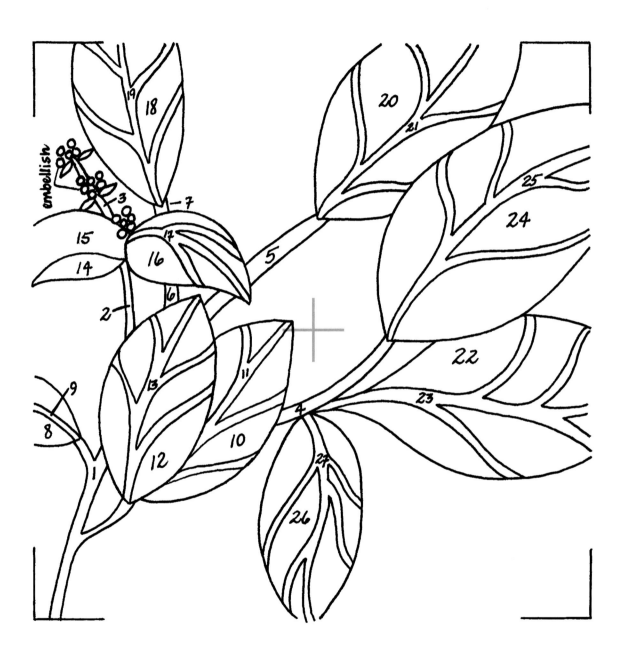

BASIL

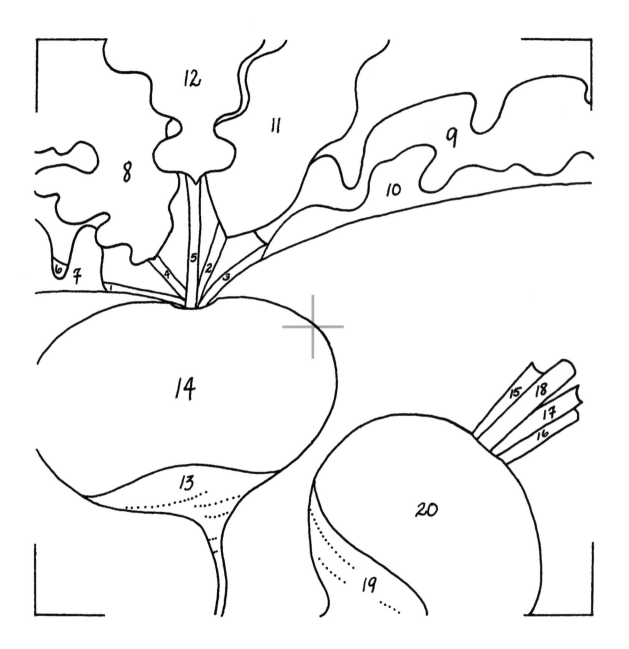

BEETS

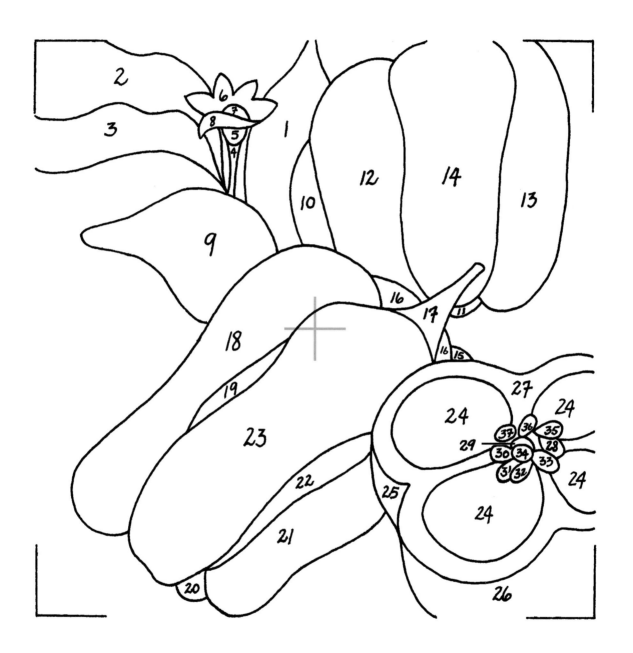

BELL PEPPERS

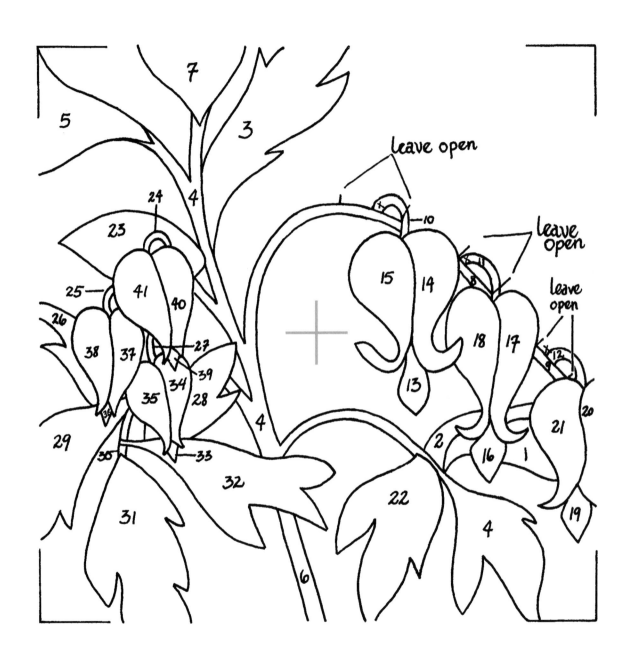

BLEEDING HEARTS

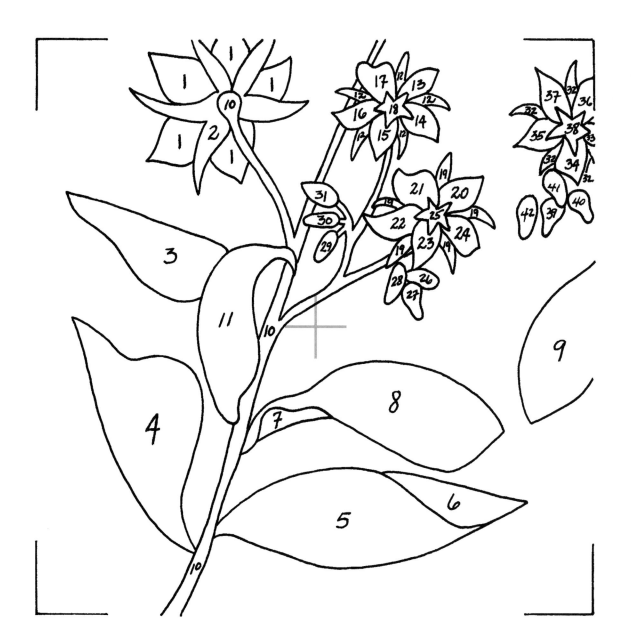

BORAGE

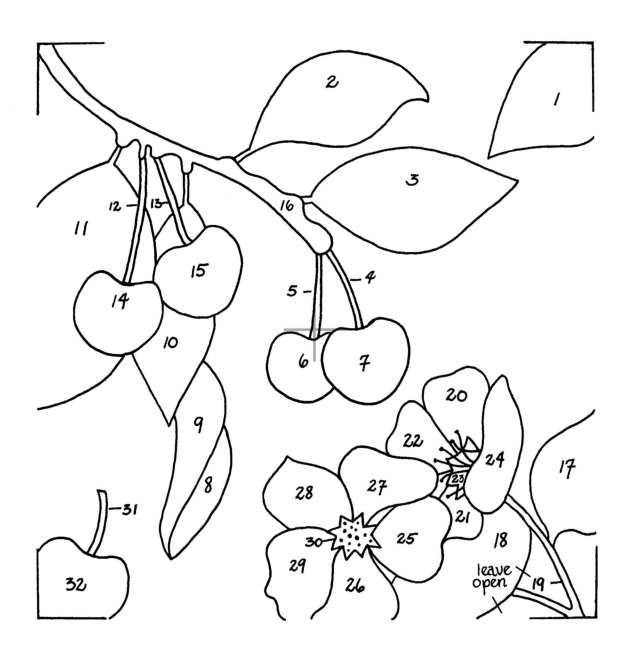

CHERRIES

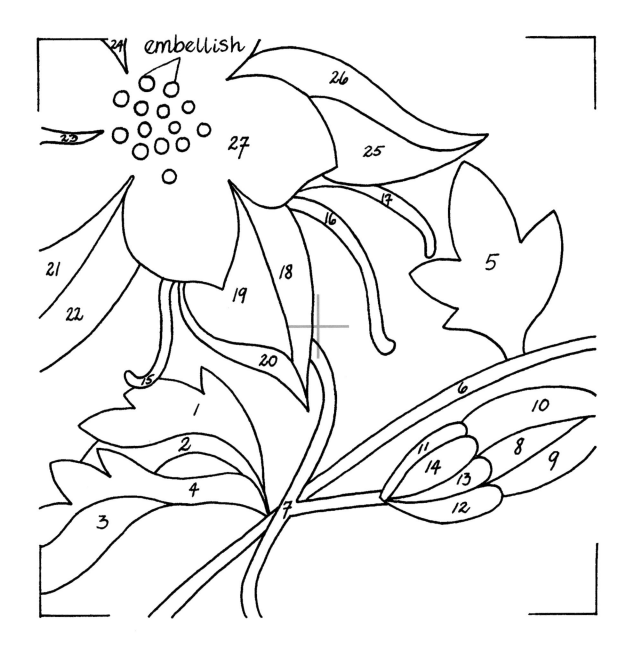

C O L U M B I N E

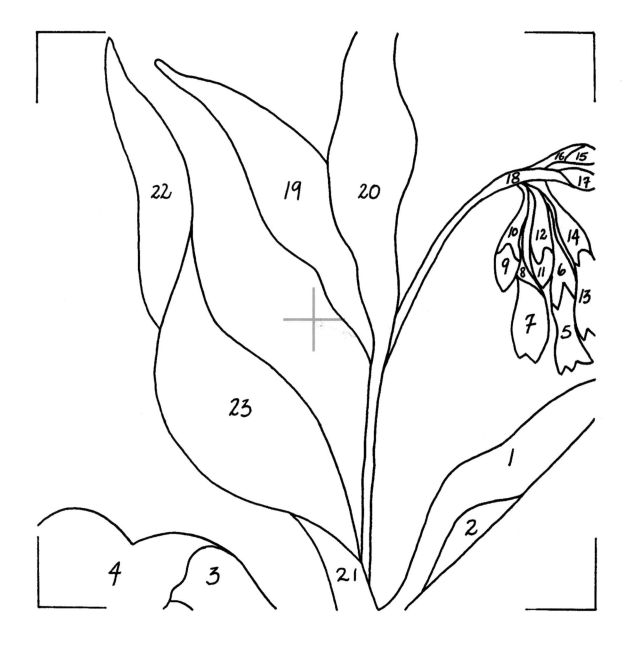

COMFREY

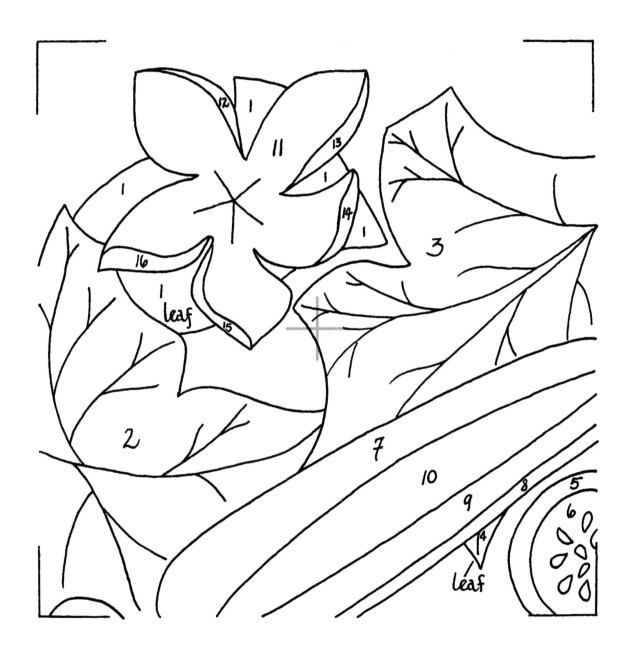

CUCUMBER

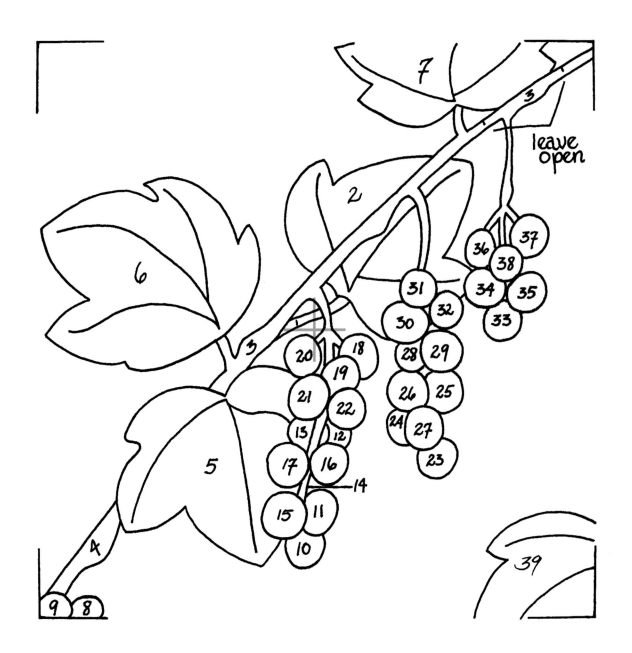

CURRANTS

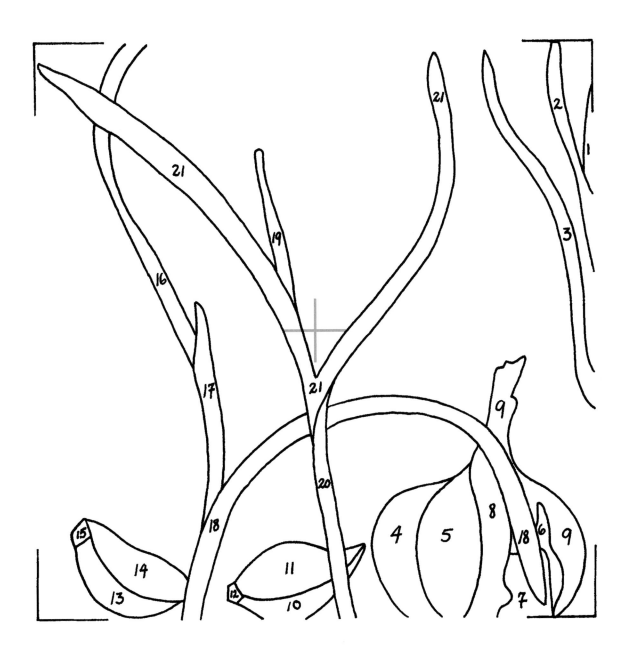

GARLIC

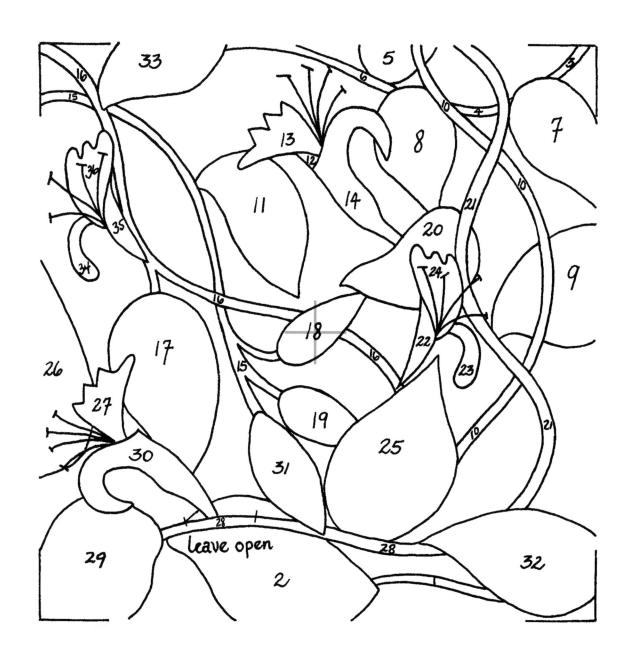

HONEYSUCKLE

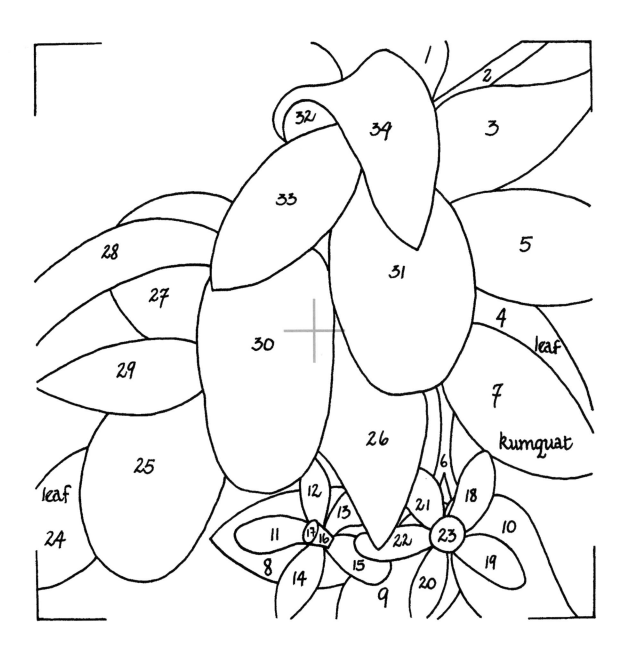

KUMQUATS

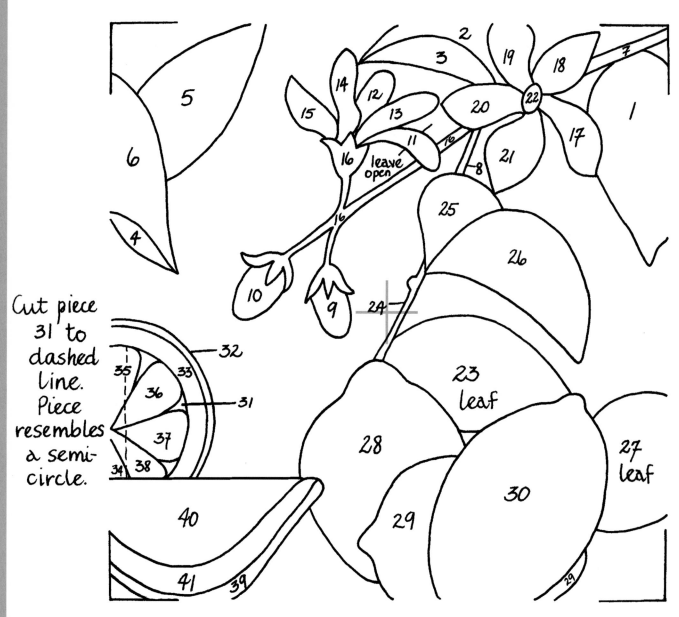

Cut piece
31 to
dashed
line.
Piece
resembles
a semi-
circle.

LEMONS

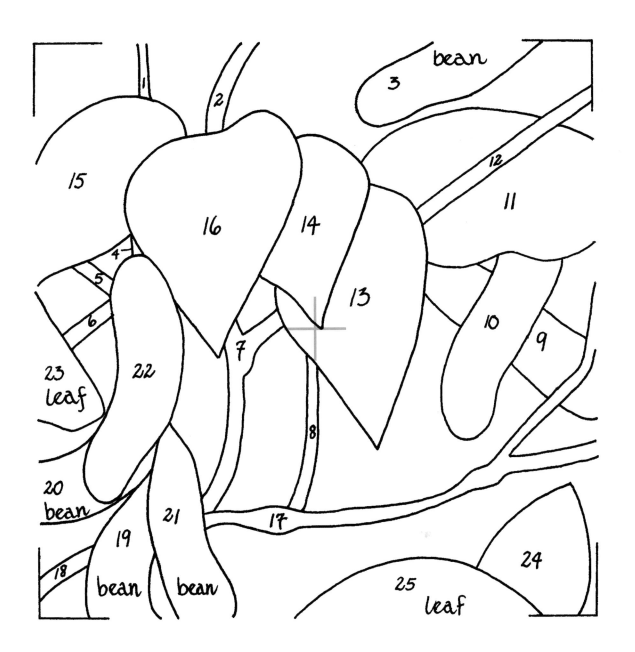

LIMA BEANS

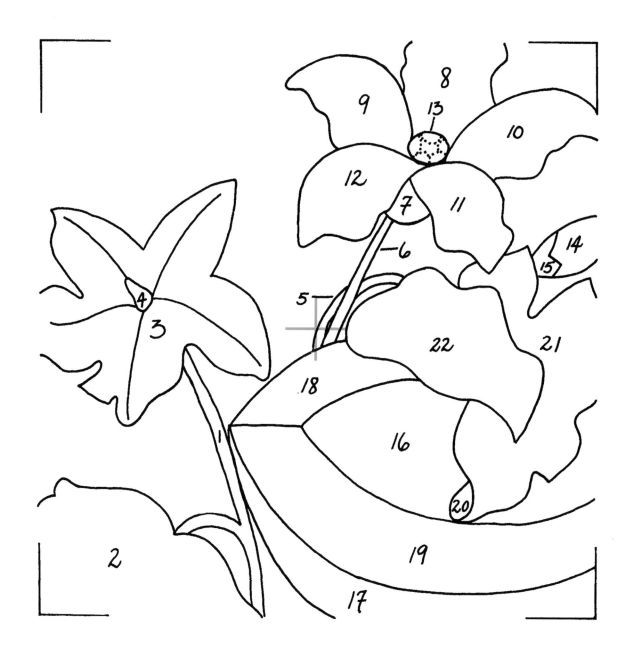

MELON

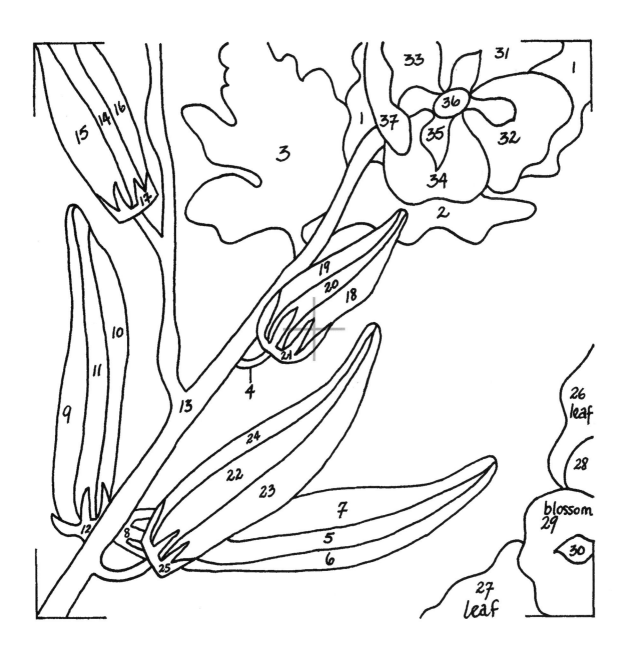

OKRA

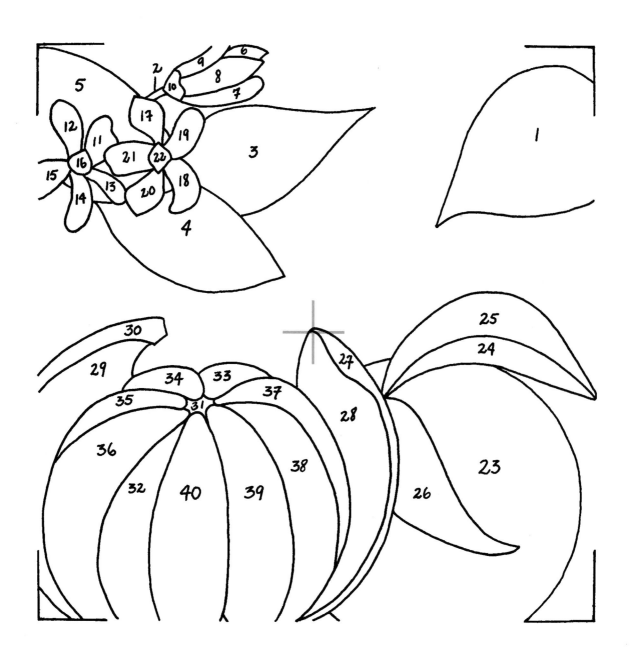

ORANGES

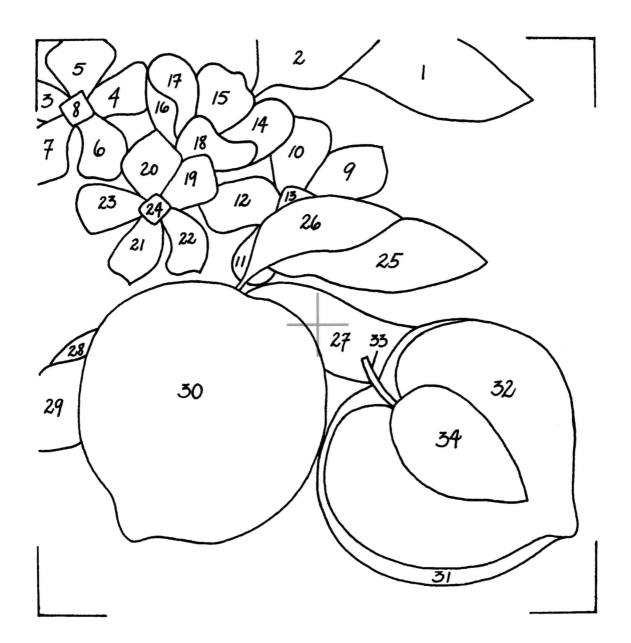

PEACHES

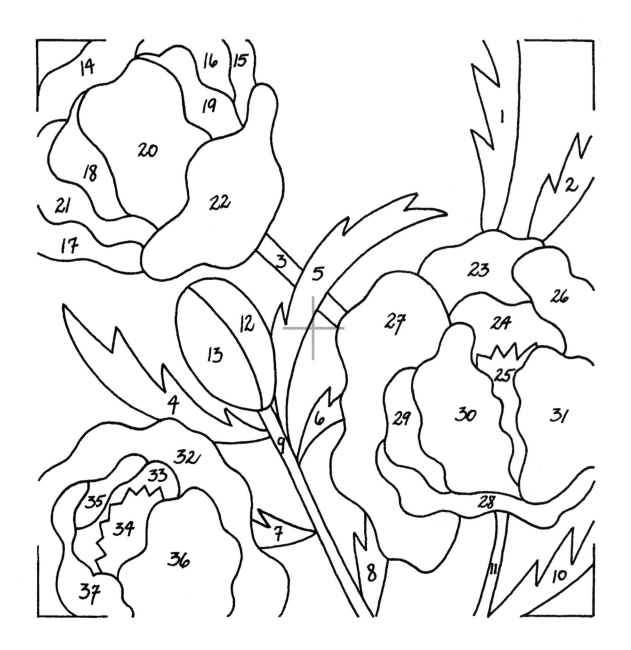

POPPIES

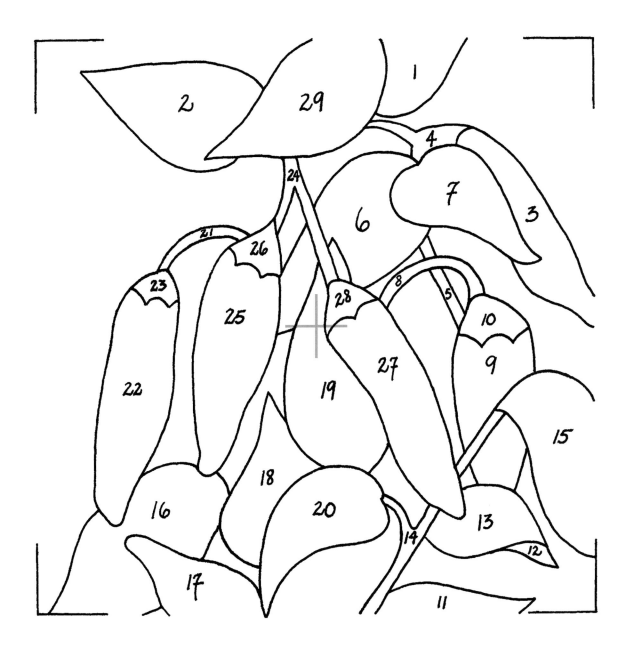

SERRANO CHILIES

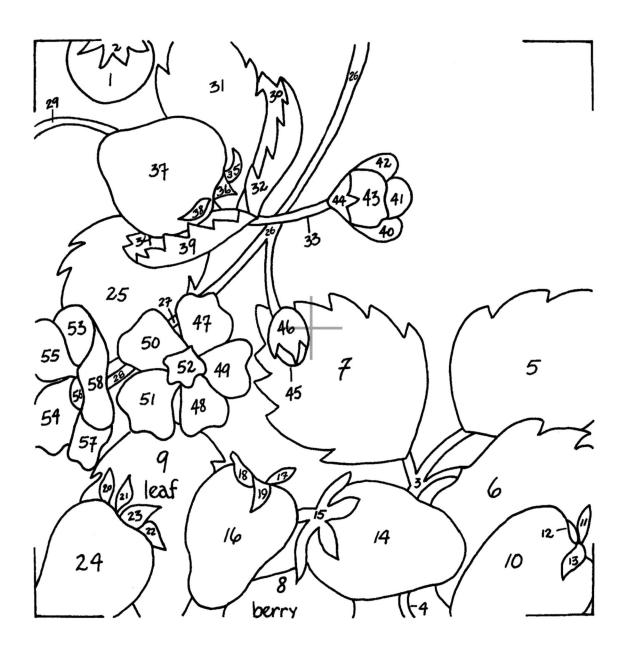

STRAWBERRIES

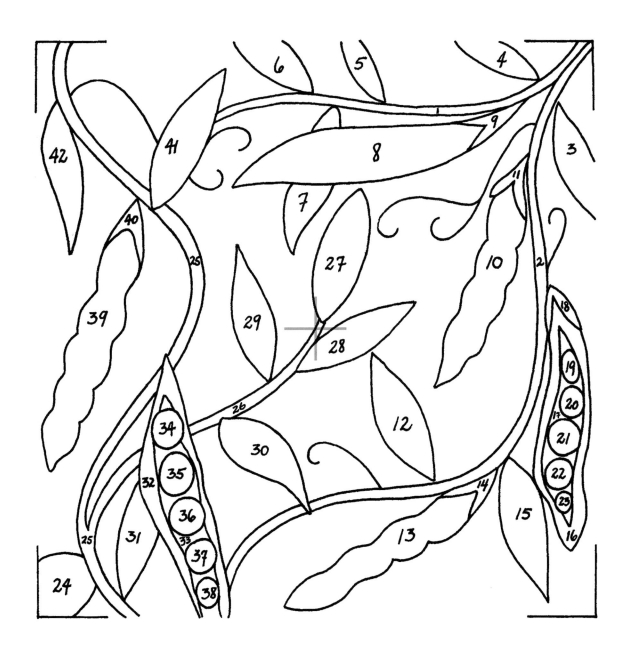

SUGAR PEAS

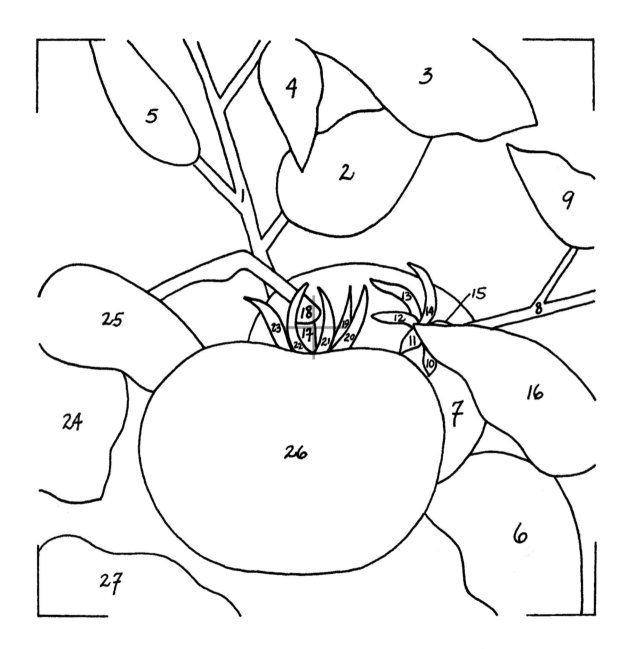

TOMATOES

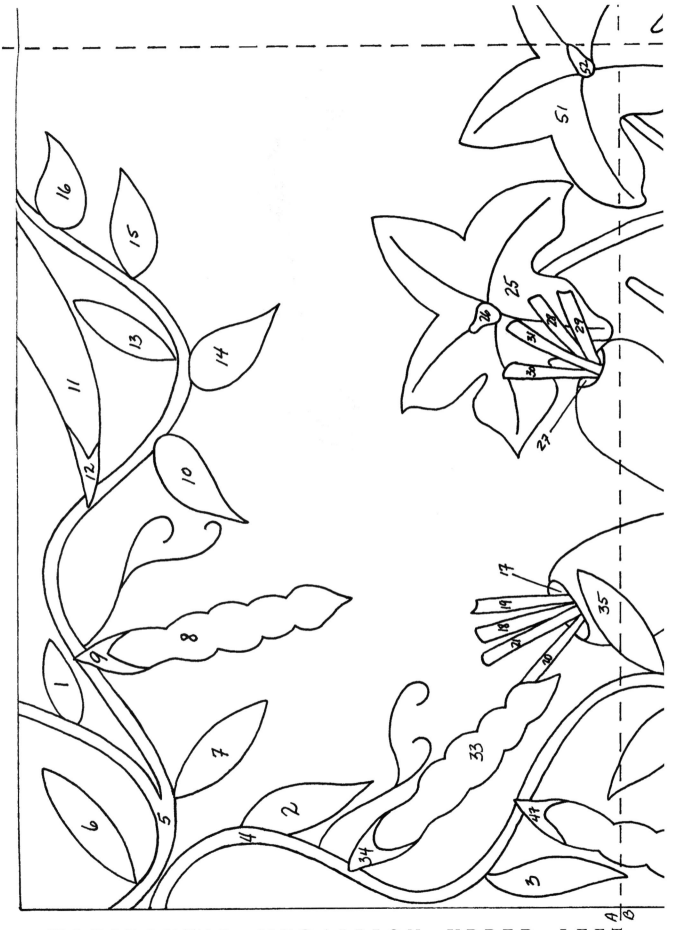

HORIZONTAL MEDALLION UPPER LEFT

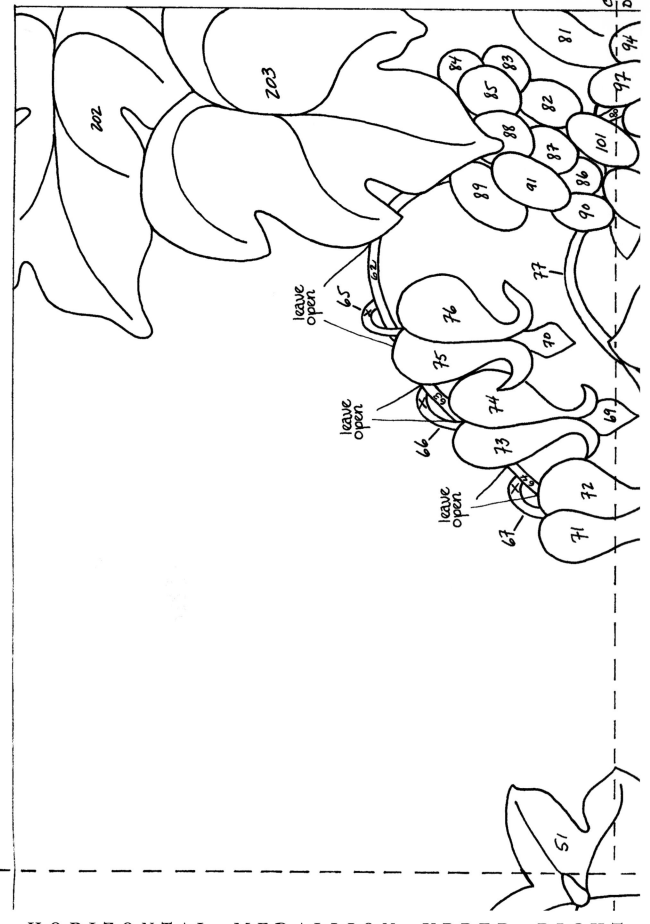

HORIZONTAL MEDALLION UPPER RIGHT

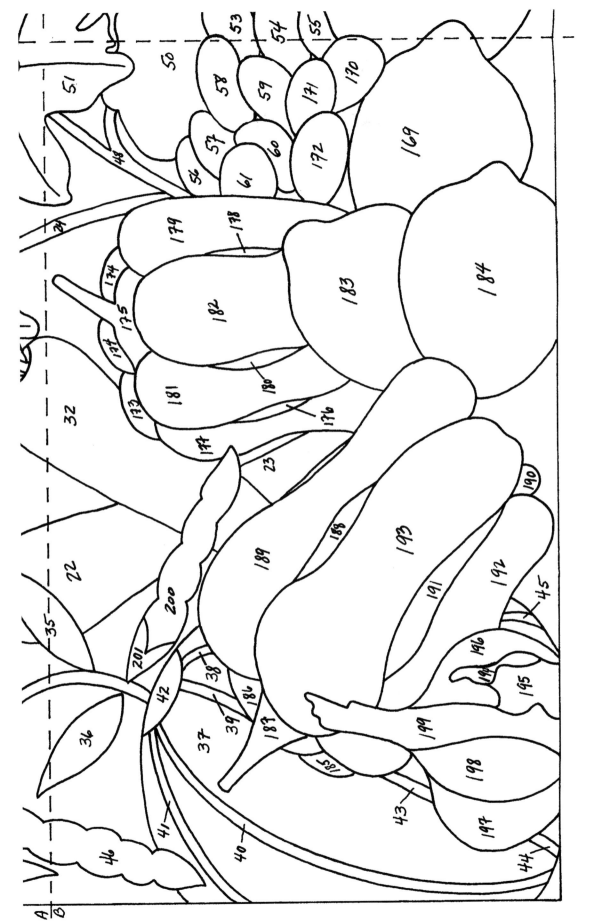

HORIZONTAL MEDALLION LOWER LEFT

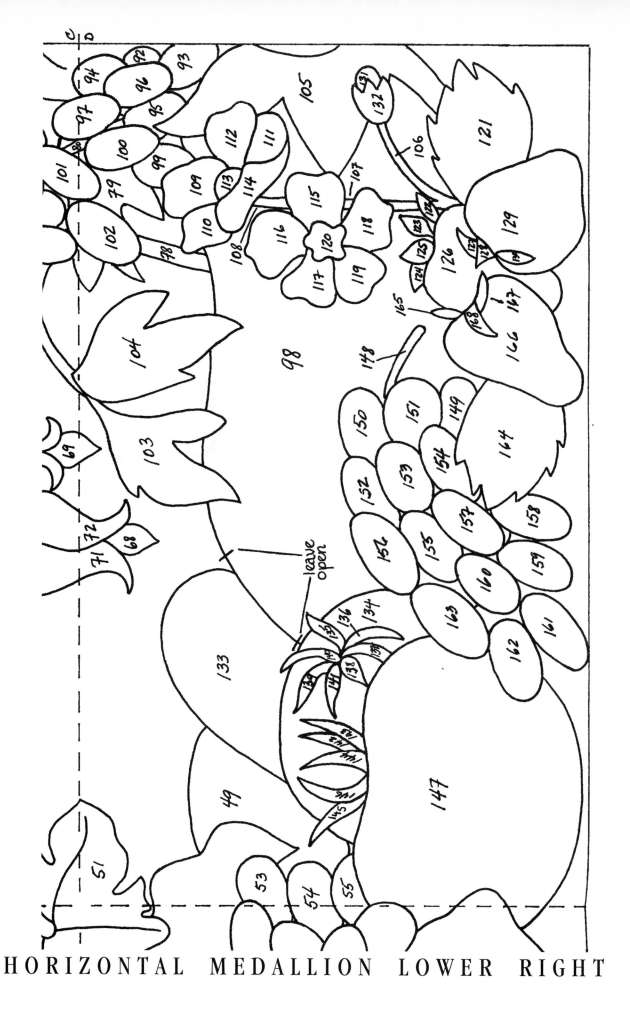

HORIZONTAL MEDALLION LOWER RIGHT

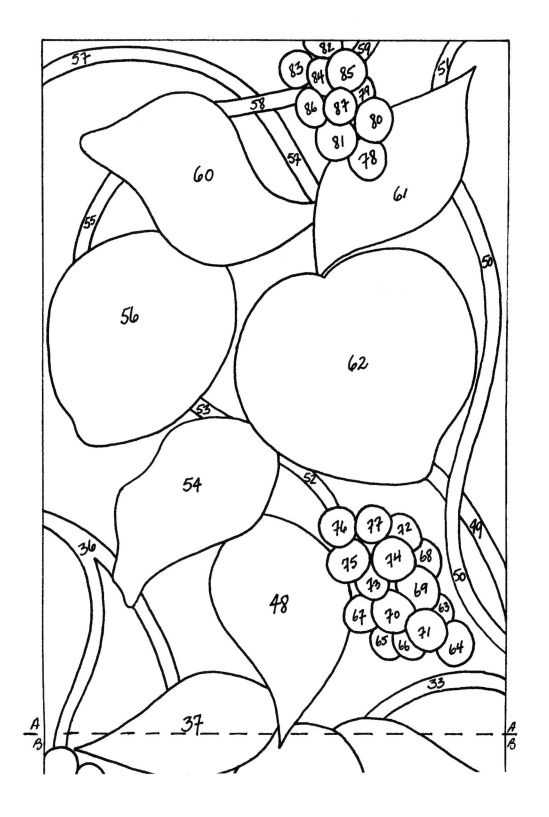

VERTICAL MEDALLION TOP

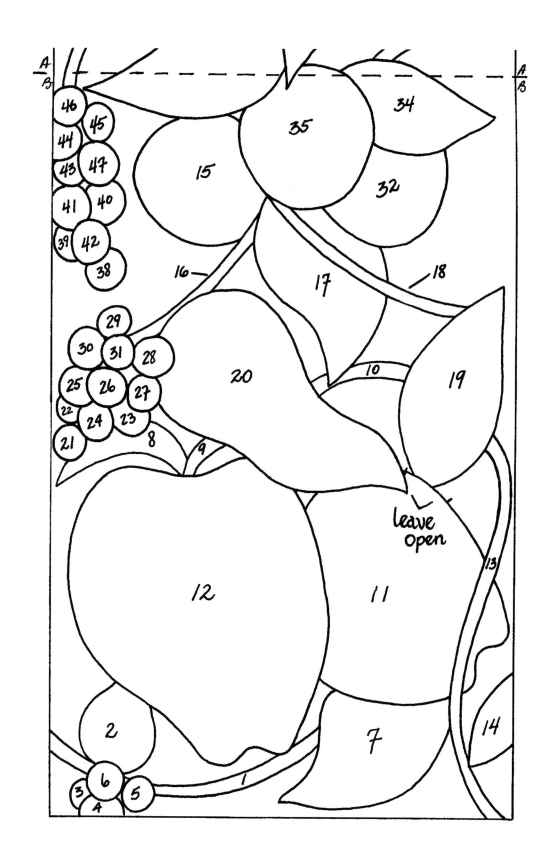

VERTICAL MEDALLION BOTTOM

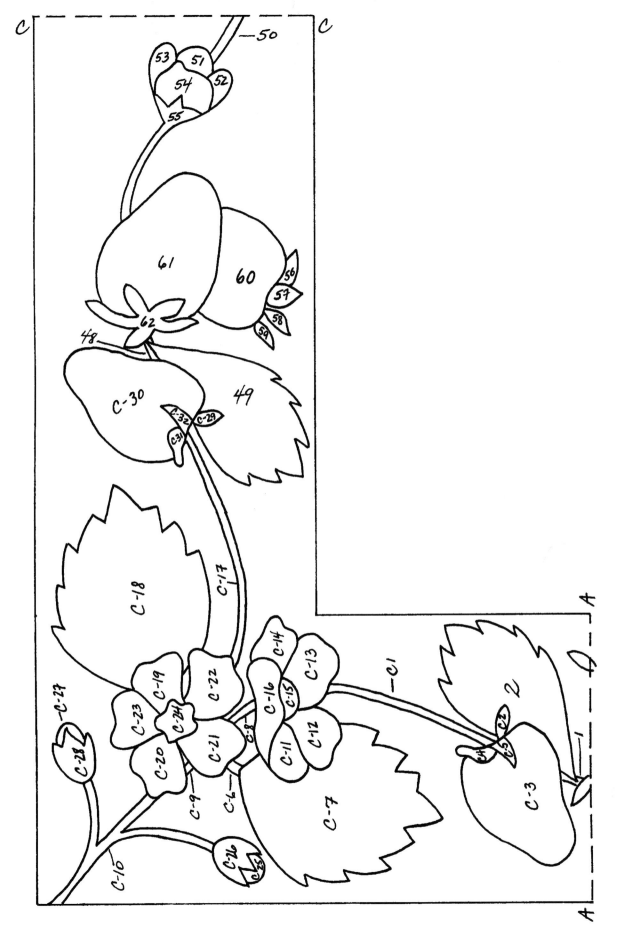

STRAWBERRIES & BLOSSOMS CORNER

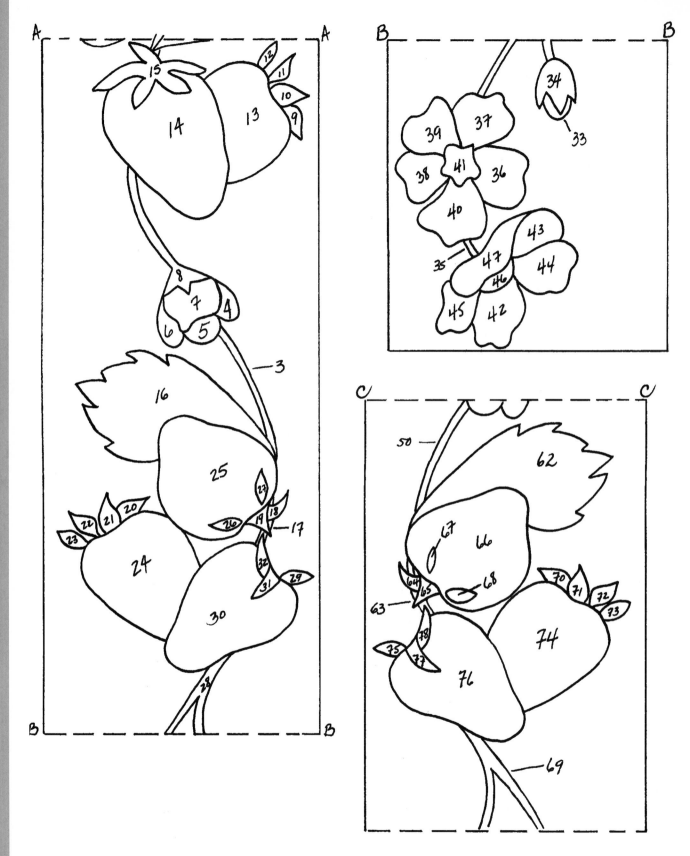

STRAWBERRIES & BLOSSOMS SIDES

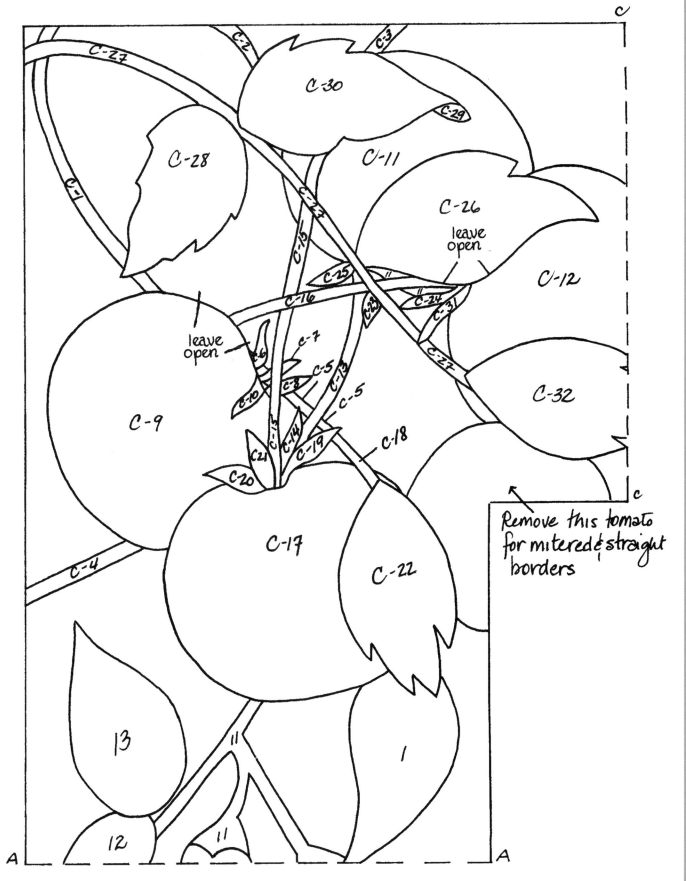

Remove this tomato for mitered & straight borders

TOMATOES & CHILI PEPPERS CORNER

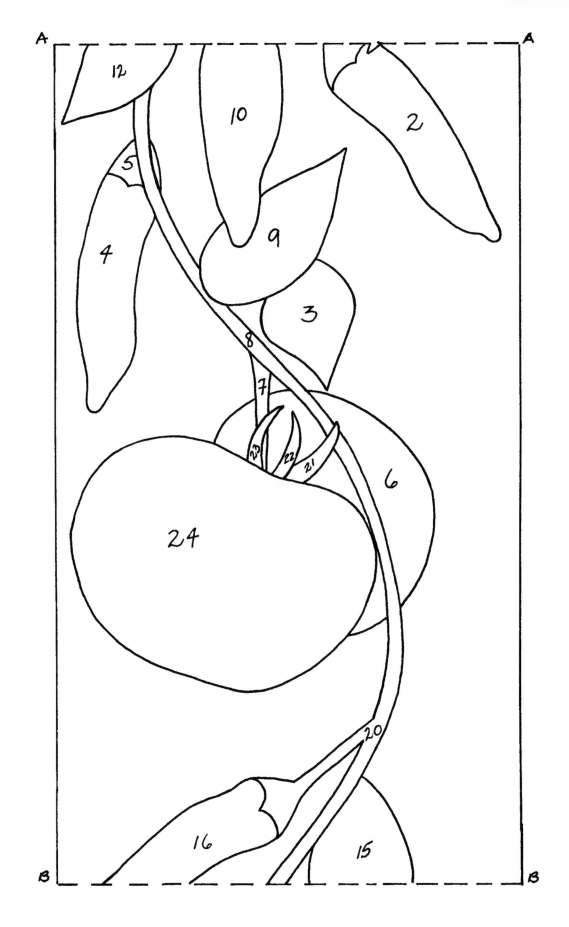

TOMATOES & CHILI PEPPERS A–B1

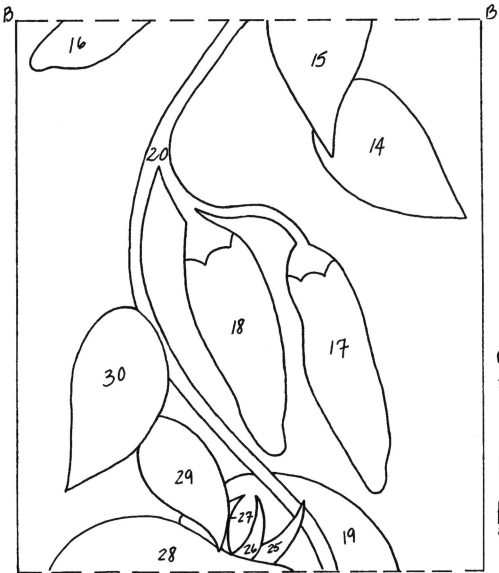

B B

16

15

14

20

18

17

30

29

27

26 25

28

19

To continue the border design, match pieces 28 & 19 to pieces 24 & 6 on page 108.

TOMATOES & CHILI PEPPERS B2

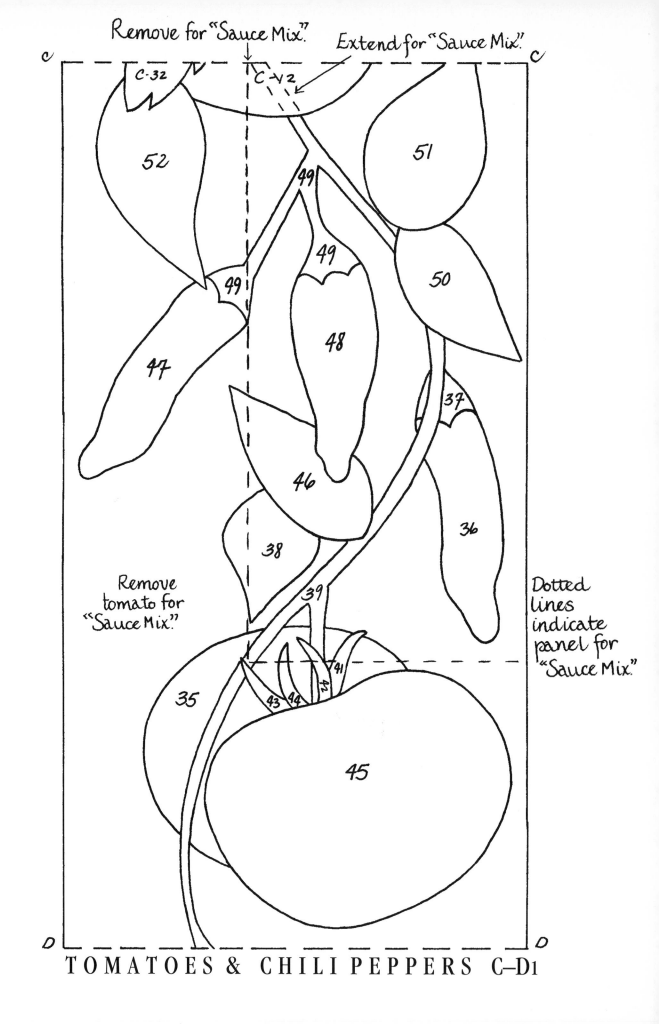

Remove for "Sauce Mix".

Extend for "Sauce Mix".

C-32

C-V2

Remove tomato for "Sauce Mix."

Dotted lines indicate panel for "Sauce Mix."

T O M A T O E S & C H I L I P E P P E R S C–D1

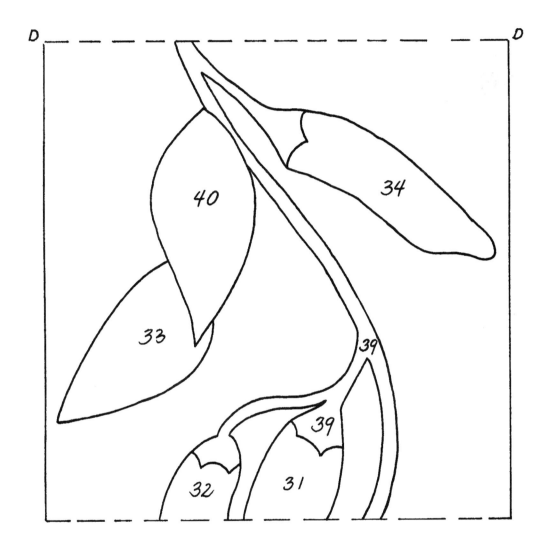

TOMATOES & CHILI PEPPERS D2

finishing
TECHNIQUES

Borders

Borders frame the quilt. Pieced, appliquéd, or cut from a single strip of fabric, borders add drama. Always consider the sophistication of an asymmetrical border. Take care, however, that borders do not become more important than the quilt they are framing! Complex quilts often benefit from simple borders, which give the eye a rest from the intricate center design.

If you don't want to piece your borders, purchase plenty of fabric and cut border strips along the lengthwise grain, parallel to the selvages.

If you don't mind the look of pieced borders, cut border strips across the width of the fabric, from selvage to selvage. You may need to join several strips. Since pieced borders require less fabric, they are more economical than unpieced strips cut lengthwise.

STRAIGHT-CUT BORDERS

1. Measure across the center of the quilt top from side to side. Cut border strips to this measurement, piecing if necessary. Measuring across the center of the quilt ensures a flat, square border.

Measure and mark center
of quilt and borders.

2. Mark the center points along the top and bottom edges of the quilt top. Mark the center of each border. Mark additional points along the quilt and border if desired. Match markings, pin, and sew the top and bottom borders to the quilt top.

3. Measure through the center of the quilt from top to bottom, including the borders just added. Cut side border strips to this measurement, piecing if necessary.

4. Mark the quilt top and borders as you did in step 2, then pin and sew the borders to the sides of the quilt top.

Measure and mark center
of quilt and borders.

MITERED BORDERS

1. Measure the width and length of the quilt top across the center, as described in step 1 of "Straight-Cut Borders" above. Cut border strips to these dimensions, adding 2 times the border width plus 2" to 3" for seam allowances. For example, for a 3"-wide border, cut strips the length and width of the quilt plus 8" to 9" {2(3") + 3" = 9"}. If you are planning multiple borders, sew individual border strips together and treat them as 1 unit for mitering.

Treat multiple borders as a
single strip when mitering.

2. Mark the center point on each border strip. On the top and bottom borders, measure half the width of the quilt on each side of the center point and mark. On the side borders, measure half the length of the quilt and mark. On the quilt top, mark the center on each side.

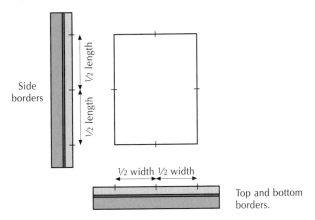

Side borders

½ length
½ length
½ length

½ width ½ width

Top and bottom borders.

3. Match the markings, pin, then sew the borders to the quilt top. Start and stop stitching ¼" from each corner of the quilt top.

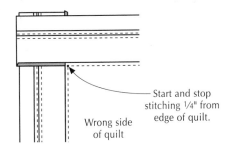

Start and stop stitching ¼" from edge of quilt.

Wrong side of quilt

4. Place the first corner to be mitered on the cutting table, wrong side up. Fold the quilt top diagonally and align the borders so they lie flat.

5. Place your acrylic ruler on the quilt with the 45°-angle mark on the stitching line and the edge of the ruler at the point where you stopped stitching. The edge of the ruler should also line up with the diagonal fold in the quilt.

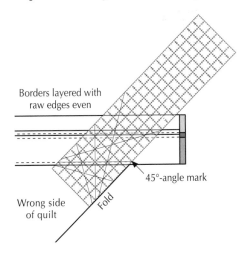

Borders layered with raw edges even

45°-angle mark

Wrong side of quilt

Fold

6. With a sharp pencil, draw along the edge of the ruler, starting at the end of the seam joining the border to the quilt top. Turn the quilt top over so the other border is on top and mark in the same fashion.

7. With right sides together, carefully pin the drawn lines together, matching at several places. Stitch along the drawn line, remove the pins, and check the miter for accuracy. Trim the seam allowances to ¼" and press open. Repeat for the remaining 3 corners. Always stitch from the quilt top toward the border edge. This eases any fullness away from the center of the miter.

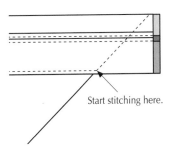

Start stitching here.

Quilting

This is the time to add even more texture and dimension to the quilt. Since the feature blocks and medallions are so compact, there is not much room for elaborate quilting. Having said that, too little quilting can cause the background to wrinkle or appear puffy. A good compromise is to begin by quilting around all the appliqué elements. This allows the batting to plump up behind the appliqué, creating more dimension.

Many quiltmakers choose not to quilt inside the appliqué designs. However, quilting vein lines in leaves adds realistic definition. Look through the quilts in the gallery. Some have quilting within the appliqué; some do not. Make this choice as you view your quilt. If quilting in the appliqué elements would add texture or dimension, use this to your advantage.

Straight-line or geometric quilting enhances quilts with organic or curvilinear designs. Curvilinear quilting works well on geometric pieced quilts. The traditional Baptist Fan design used on so many antique quilts is a perfect example of curvilinear quilting on a pieced top.

Geometric background quilting—whether straight lines, diagonal lines, cross-hatching, or channel quilting—draws attention to appliqué in two ways: The quilting lines make the background fabric recede, while at the same time pushing the appliqué forward. In "Potpourri" on page 49, diagonal lines spaced 1" apart in the background add visual interest.

Aim for even quilting stitches. Small, even stitches will come with practice. Meanwhile, five even stitches per inch are far more beautiful than twelve uneven stitches. A good way to hide your stitches is to use thread that matches the fabric you are quilting.

If you have not quilted on anything in a while, practice first. I keep a practice sandwich handy to help me get into a rhythm. Practicing ten to fifteen minutes a day rapidly improves your quilting skills.

For more technical information on quilting, refer to *Loving Stitches* by Jeana Kimball.

Binding

Binding is the last design element added to the quilt. Decorative bindings make a final statement. Try striped fabric cut on the bias or binding cut from strip-pieced fabrics for added color. Contrasting bindings give the quilt a dramatic ending that strongly delineates the edges.

My preference is for French-fold binding. It is easy to use and the double fold wears well.

1. Fold the binding strip in half lengthwise, wrong sides together. Press.
2. Place the binding on the front of your quilt, raw edges even, and stitch using a seam allowance equal to the desired width of the binding (¼" for the 2" cut bindings in this book).
3. Fold the binding to the back side of the quilt and hand stitch in place.

Happy Endings by Mimi Dietrich is the best reference book I have found on binding. I still refer to it whenever I have a technical question.

Curtain Call

Applause . . . applause . . . applause! Take a bow. Your quilt is finished. Wait—come back out on stage. What's your name?

This is just my way of saying, "Name your quilt and tell us who you are." Making a label for your quilt is not only important historically but also to your family. Painters sign their work. Why shouldn't quiltmakers?

If you do not feel like making a label, sign your name directly on the quilt using a permanent-ink pen, or embroider your name on the back or front. Whatever method you choose, be sure that someday someone else will know who made the quilt.

Having the Last Word

So here we are once again at the end of the quiltmaking process. It is the process that keeps me making quilts. With each finished quilt, I am on to the next one. I always look forward to what I will learn from the next project. Each and every quilt has

a voice of its own. From listening to that voice, I discovered more about myself and my work.

Play, make mistakes, and push yourself to do the unexpected. I hope you find joy and comfort in all the quilts you make. I am looking forward to seeing your next quilt!

about the AUTHOR

Gabrielle Swain is a studio quilt artist whose work has been shown nationally and internationally. She has taught quiltmaking locally and regionally since 1985. Since the publication of *Appliqué in Bloom,* traveling and teaching have been exciting adventures for Gabrielle. "Teaching and meeting other quiltmakers keeps me inspired to do more work. I always look forward to seeing what other quiltmakers are doing and helping them, if I can, accomplish new work."

The body of her work has been nontraditional, but appliqué has always been her technique of choice. Nature offers so many design possibilities for appliqué that Gabrielle has chosen to spend the next few years working with nature only. *From a Quilter's Garden* is a continuation of the contemporary floral appliqué in *Appliqué in Bloom.* This style allows Gabrielle to combine her award-winning design skills with her continuing love of appliqué. She says, "I would rather appliqué than eat . . .well, almost."

Gabrielle and her husband, Ron, have managed to move another son to his own home in the past year. They now share their Texas home with sons Chris and Thomas and the family guinea pig, Ethel. Gabrielle is one of the founding members of North Texas Quilt Artist and is also a member of the American Quilter's Society, and the Studio Art Quilt Association.

resources

Hand-painted and hand-dyed fabrics give any appliqué a special feel. The following artists produce some of my favorite fabrics. I find them irresistible for contemporary floral appliqué.

Painted Pieces
4236 Rush Springs Drive
Arlington, TX 76016
(817) 478-3918

Artist: Laura McGee

Fabrics from Laura are a must for beautiful color and shading in fruits, vegetables, herbs, and flowers. She also makes wonderful background fabrics. All Laura's fabrics are individually hand painted on high-quality Pima cotton.

Skydyes
83 Richmond Lane
West Hartford, CT 06117
(203) 232-1429

Artist: Mickey Lawler

Mickey painted the background fabric I used in "Juicy Fruit" on page 47. I wish you could see it in person. The depth of color and value in Mickey's fabric makes it invaluable for any appliqué work. Skydyes are painted on high-quality Pima cotton.

Cherrywood Fabrics, Inc.
PO Box 486
Brainerd, MN 56401-0486
(218) 829-0967

Artist: Dawn Hall

All the gradated fabrics in the gallery are from Cherrywood Fabrics. Dawn has created beautiful, consistent gradations in a wide variety of colors. Just looking at her color card entices me to work.

Art Spoken Yardage
30 South Saint Albans
Saint Paul, MN 55105
(612) 222-2483

Artist: Merit Lee Kucera

Merit's echo designs are perfect for flowers and leaves. No two pieces of this hand-dyed fabric are alike.

Shades, Inc.
1-800-783-DYED

Artist: Stacy Michell

I never walk into Stacy's booth at any show without seriously decreasing my bank account. The background fabric in "Salsa Days" on page 48 is just one selection from Stacy's incredible collection of hand-dyed fabrics. I love to use her sky fabrics for backgrounds, but she also produces wonderful special-effect fabrics that I use for flowers and leaves.

Books from Martingale & Company

Appliqué

Appliquilt® Your ABCs
Appliquilt® to Go
Baltimore Bouquets
Basic Quiltmaking Techniques for Hand Appliqué
Coxcomb Quilt
The Easy Art of Appliqué
Folk Art Animals
From a Quilter's Garden
Stars in the Garden
Sunbonnet Sue All Through the Year
Traditional Blocks Meet Appliqué
Welcome to the North Pole

Borders and Bindings

Borders by Design
The Border Workbook
A Fine Finish
Happy Endings
Interlacing Borders
Traditional Quilts with Painless Borders

Design Reference

All New! Copy Art for Quilters
Blockbender Quilts
Color: The Quilter's Guide
Design Essentials: The Quilter's Guide
Design Your Own Quilts
Fine Art Quilts
Freedom in Design
The Log Cabin Design Workbook
Mirror Manipulations
The Nature of Design
QuiltSkills
Sensational Settings
Surprising Designs from Traditional Quilt Blocks
Whimsies & Whynots

Foundation/Paper Piecing

Classic Quilts with Precise Foundation Piecing
Crazy but Pieceable
Easy Machine Paper Piecing
Easy Mix & Match Machine Paper Piecing
Easy Paper-Pieced Keepsake Quilts
Easy Paper-Pieced Miniatures
Easy Reversible Vests
Go Wild with Quilts
Go Wild with Quilts—Again!
A Quilter's Ark
Show Me How to Paper Piece

Hand and Machine Quilting/Stitching

Loving Stitches
Machine Needlelace and Other
 Embellishment Techniques
Machine Quilting Made Easy
Machine Quilting with Decorative Threads
Quilting Design Sourcebook
Quilting Makes the Quilt
Thread Magic
Threadplay with Libby Lehman

Home Decorating

Decorate with Quilts & Collections
The Home Decorator's Stamping Book
Living with Little Quilts
Make Room for Quilts
Soft Furnishings for Your Home
Welcome Home: Debbie Mumm

Miniature/Small Quilts

Beyond Charm Quilts
Celebrate! with Little Quilts
Easy Paper-Pieced Miniatures
Fun with Miniature Log Cabin Blocks
Little Quilts All Through the House
Lively Little Logs
Living with Little Quilts
Miniature Baltimore Album Quilts
No Big Deal
A Silk-Ribbon Album
Small Talk

Needle Arts/Ribbonry

Christmas Ribbonry
Crazy Rags
Hand-Stitched Samplers from I Done My Best
Miniature Baltimore Album Quilts
A Passion for Ribbonry
A Silk-Ribbon Album
Victorian Elegance

Quiltmaking Basics

Basic Quiltmaking Techniques for Hand Appliqué
Basic Quiltmaking Techniques for Strip Piecing
The Joy of Quilting
A Perfect Match
Press for Success
The Ultimate Book of Quilt Labels
Your First Quilt Book (or it should be!)

Rotary Cutting/Speed Piecing

Around the Block with Judy Hopkins
All-Star Sampler
Bargello Quilts
Block by Block
Down the Rotary Road with Judy Hopkins
Easy Star Sampler
Magic Base Blocks for Unlimited Quilt Designs
A New Slant on Bargello Quilts
Quilting Up a Storm
Rotary Riot
Rotary Roundup
ScrapMania
Simply Scrappy Quilts
Square Dance
Start with Squares
Stripples
Stripples Strikes Again!
Strips that Sizzle
Two-Color Quilts

Seasonal Quilts

Appliquilt® for Christmas
Christmas Ribbonry
Easy Seasonal Wall Quilts
Folded Fabric Fun
Quilted for Christmas
Quilted for Christmas, Book II
Quilted for Christmas, Book III
Quilted for Christmas, Book IV
Welcome to the North Pole

Surface Design/Fabric Manipulation

15 Beads: A Guide to Creating One-of-a-Kind Beads
The Art of Handmade Paper and Collage
Complex Cloth: A Comprehensive Guide
 to Surface Design
Dyes & Paints: A Hands-On Guide to Coloring Fabric
Hand-Dyed Fabric Made Easy

Theme Quilts

The Cat's Meow
Celebrating the Quilt
Class-Act Quilts
The Heirloom Quilt
Honoring the Seasons
Kids Can Quilt
Life in the Country with Country Threads
Lora & Company
Making Memories
More Quilts for Baby
Once Upon a Quilt
Patchwork Pantry
Quick-Sew Celebrations
Quilted Landscapes
Quilted Legends of the West
Quilts: An American Legacy
Quilts for Baby
Quilts from Nature
Through the Window and Beyond
Tropical Punch

Watercolor Quilts

Awash with Colour
Colourwash Quilts
More Strip-Pieced Watercolor Magic
Strip-Pieced Watercolor Magic
Watercolor Impressions
Watercolor Quilts

Wearables

Crazy Rags
Dress Daze
Dressed by the Best
Easy Reversible Vests
Jacket Jazz
More Jazz from Judy Murrah
Quick-Sew Fleece
Sew a Work of Art Inside and Out
Variations in Chenille

Many of these books are available through your local quilt, fabric, craft-supply, or art-supply store. For more information, call, write, fax, or e-mail for our free full-color catalog.

Martingale & Company
PO Box 118
Bothell, WA 98041-0118 USA

1-800-426-3126
International: 1-425-483-3313
24-Hour Fax: 1-425-486-7596
Web site: www.patchwork.com
E-mail: info@patchwork.com